# GRAPHY

Kathleen McCarthy Gauss

LOS ANGELES COUNTY MUSEUM OF ART

Text and illustrations copyright ©1985 by Museum Associates,
Los Angeles County Museum of Art

Edited by Kathleen Preciado
Designed by Deenie Yudell and Sandy Bell
Text typography in Bell and Futura typefaces by Mondo Typo,
Santa Monica, California
Title typography by Aldus Type Studio, Ltd., Los Angeles, California
Printed in an edition of 3,500 on one-hundred-pound Mead
black & white enamel dull by Gardner/Fulmer Lithograph,
Buena Park, California

20 04004 989

Library of Congress Cataloging in Publication Data

Gauss, Kathleen McCarthy.
    New American photography.

    Catalogue of seven one-person exhibitions held at the museum
from 1983 to 1985.
    1.   Photography, Artistic–Exhibitions.
I.   Los Angeles County Museum of Art.      II. Title.
TR646.U6L654      1985      779'.0973'074019494      85-9633

ISBN 0-87587-126-7

# Contents

The exhibition series New American Photography began in the fall of 1983. Complementing another museum program entitled Gallery 6, the series marks the strong commitment of the museum to contemporary art.

Organized by Associate Curator Kathleen McCarthy Gauss, New American Photography initiates the museum's photography exhibition program, which will grow substantially within the next few years. Upon completion of new gallery space in the fall of 1986, the department will realize its potential with spacious exhibition galleries. With this expansion, the museum will be able to organize large-scale exhibitions and present significant traveling exhibitions, thereby providing a major venue for photography in Los Angeles.

The future growth of the Department of Photography would not be possible without the generous support of the Ralph M. Parsons Foundation. Their substantial grant for the establishment of the department provides for a gallery for photography, expanded programs, and development of a photography collection. We are deeply grateful to them for their pivotal support. Many others too, including members of the Board of Trustees, have been instrumental in the emergence of the department, and we acknowledge their assistance over the past years.

As the opening of the Robert O. Anderson Gallery is eagerly anticipated, we also look forward to the expansion of gallery space that will enable the museum to undertake an ambitious and comprehensive program including exhibitions of historical photography as well as innovative contemporary work.

Earl A. Powell III
*Director, Los Angeles County Museum of Art*

Τ his publication is a catalogue of seven one-person exhibitions from the ongoing series New American Photography. Accordingly, the volume is organized into seven discrete chapters, following the sequence of the exhibitions, each with a brief essay and portfolio of images. These seven artists are not part of a group nor are they linked in any manner beyond their inclusion here. Focusing on the development of the artists' primary concepts, the exhibitions are drawn from work chiefly executed during the preceding two or three years. Occasionally earlier works are included to illustrate major shifts or long-standing interests.

The exhibition series was devised to bring to Los Angeles outstanding work by artists from across the country as well as southern California. Naturally, as is always the case, no small number of artists can fully represent the entire medium. These exhibitions do not claim to cover all aspects of contemporary photography, only seven divergent attitudes toward it. Thus, the catalogue represents the pluralism indicative of the medium, ranging from the more traditional landscape photographs and portraits to monumental experimental panels.

Although photography encompasses an enormous range, from documentary to conceptual, its definition in the public mind tends to be synonymous with the aesthetics of noted historical work rather than photography at its most experimental. This series at the Los Angeles County Museum of Art attempts to address the range of the medium but is also mindful of the need to recognize innovative work and the expanding potential of photography as a contemporary art form.

This exhibition program, indeed the existence of the Department of Photography, has been enthusiastically supported by Director Earl A. Powell III and the Board of Trustees. In undertaking these exhibitions, I have been fortunate to have received the assistance of many within the museum. This volume would not have been realized without the approval of Assistant Director for Museum Programs Myrna Smoot and thoughtful assistance of Managing Editor Mitch Tuchman. Through the patient efforts of editor Kathleen Preciado and skillful talents of graphic designers Deenie Yudell and Sandy Bell, the material has been organized into its elegant form. Excellent reproductions were prepared by staff photographer Jeffrey Conley; the works of Susan Rankaitis were photographed by John Eden. All the artists accommodated the specific needs of the publication and were most helpful. Outside the museum, Ellen Manchester, Rhona Hoffman, and Martha Charoudi offered assistance in obtaining material.

Kathleen McCarthy Gauss
*Associate Curator, Department of Photography*

# Susan Rankaitis

While the materials and processes employed in the large-scale monoprints of Susan Rankaitis are unquestionably photographic, the formal aspects of her work and approach originate in painting. By virtue of their size, fluid washes of metallic color, and uniqueness, her monoprints have far more affinity to painting than photography.

Her background in painting is reflected in her monoprints in various ways. The development of an extended oeuvre, thoroughly mining certain basic material, is a concept derived by Rankaitis from contemporary painters, particularly Mark Rothko and Richard Diebenkorn. The heroic aspect of her work has been informed as well as by a subtle abstraction. The loose montage application of photographic images has precedence in the seminal work of Robert Rauschenberg, both paintings and prints. Irrespective of these general sources, however, Rankaitis's monoprints have emerged without direct antecedents in photography or painting. The concept of dichotomy is of fundamental interest for Rankaitis and in many ways is reflected in her choice of subject and medium. Her prints are midway between imagery and abstraction, color and noncolor, photography and painting.

Like a number of women artists in Los Angeles using photography, Rankaitis has never had an interest in the traditional, more documentary uses of the medium and has always made her works within the studio. Concerned more with abstraction, she uses the photographic negative as a component rather than the essence of the final print. Unwilling to relinquish her interest in painting, she experimentally applies various photographic emulsions, brushed or sprayed onto the paper, incorporating imagery at various levels. Because of the uniqueness of her method, her works are necessarily one of a kind, and thus further allied with painting. Rankaitis uses light and chemistry to create new colorations within the black-and-white medium. Beginning essentially with painterly abstraction, she utilizes photographic materials in a new way, while pushing the boundaries of photography closer to painting.

To achieve the subtle tonalities of light and depth she found unobtainable with paint, Rankaitis began experimenting with photographic materials. Altering the silver structure to create abstract compositions, she follows the experimental tradition in photography from László Moholy-Nagy to those artists using nonsilver processes during the late 1960s.

The experimental impetus of Rankaitis's work is very directly related to the investigations and theories of Moholy-Nagy. Her pieces demonstrate his dictums regarding multiple imagery, montage, abstraction, and use of photograms to expand the possibilities of the medium, releasing it from mere reproduction. From Moholy-Nagy comes the exploration of the painterly options within the photographic medium. His fundamental questions regarding the nature of light and shade, brightness and darkness, and harmony are addressed in her work. Rankaitis's reuse of key icons illustrates a similar concern with time, stasis, and compositional dynamism. The enormous images projected onto paper and layers of photographic emulsion also have their source in Moholy's "New Vision."[1]

The photogram had a special significance for Moholy-Nagy, as he considered it to be the most dematerialized means of creating new work, one that transcended the necessity of the mechanical camera apparatus. It was for him, the key to photography.[2] Rankaitis extended the use of the photogram to create expansive areas of different tones and coloration. Throughout the works, dense photograms of rectilinear and angular shapes can be discerned.

On a monumental scale, she may also use large objects, such as an airplane wing, to establish form. Illegible four-by-five negatives, microfiche sheets, and other objects are also used. In certain prints Rankaitis has also incorporated solarizations. The negative image has been employed by Rankaitis further adding to the abstraction of the unmanipulated negative. This form too looks back to the 1920s.[3]

Although by 1979 Rankaitis had successfully addressed many of the problems inherent in her individual use of materials, the pieces were still unresolved, lacking a visual coherence. Nonetheless, she continued her investigations, applying experimental emulsions in a painterly manner. In an astonishing advance during 1980, Rankaitis began work on a group of large pieces, each seven feet or more high and three-and-a-half feet wide. The Fire River series successfully combined her previous experiments with a logical organizing schema.

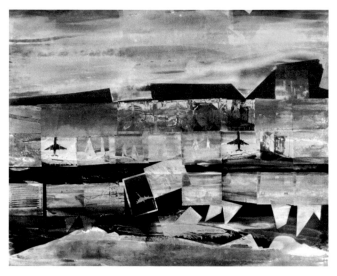

Fig. 1.   *Lake* (detail), 1980.

These works represent a profound break with previous efforts and were to serve as a strong foundation for subsequent work.[4]

*Gold/Water*, 1980 (pl. 1), and *Lake*, 1980 (pl. 2), exemplify the Fire River series. By comparison with later pieces, they are precise, delicate, and minutely detailed. Towering over the viewer, the vertical images assume a commanding, eerie presence. The constant mutability of the surface further imbues the work with a powerful vitality. The metallic sheen of the enormous sheets recalls the transitive, reflective surface of the daguerreotype. Rankaitis's prints similarly require the viewer to examine the work from several positions to appreciate all the many angles and reflections. Ironically, in reproduction the works appear more stoic and detailed, losing their reflective, changeable character and mystery.

In these early works, registers of metallic wash divide the vertical plane into numerous layers, some sharply defined and discrete, others melding into adjacent washes. Within the horizontal striations is a complex montage of four-by-five-inch negatives and microfiche sheets, combined in both negative and positive images. Sovereign in these sheets, however, are large areas of subtle, painterly coloration, which establish a contrapuntal rhythm between the broad luminous planes of shifting chromas and delicate photographic details.

*Lake* is among the earliest large works to involve aero-

nautical iconography.[5] The plane (fig. 1) is used serially and is a significant, prominent motif that would appear again in Rankaitis's work. It foreshadows the later occurrence, especially in *Prolate Habitat*, 1983 (pl. 7), of her bold repetition of certain key icons. This repetition is also drawn from Moholy-Nagy's theories. In sequence the individual picture looses its identity, becoming a detail, a structural element of the whole.[6] Although lacking specific visual references to flight, *Gold/Water* is considered by Rankaitis to be pivotal for the flight series. The repetition of images and microfiche sheets, although used formally, signals her interest in content in addition to abstraction. These two early works are on paper rather different from that of the later pieces, thus accounting for slight differences in tonality. Rankaitis found that various papers responded differently to chemical experimentation, resulting in demonstrable shifts in imagery and surface quality.

Fundamental to Rankaitis's work is the nonphotographic evolution of each piece. Beginning with a preconceived structure, the prints emerge over weeks or even months, continually undergoing change. Rankaitis constructs her prints gradually, contemplating alterations to the existing composi-

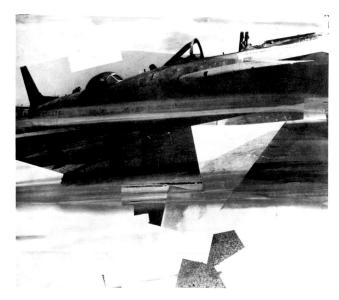

Fig. 2.   *Tail*, 1983.

tion. Since the process does not allow correction, only a few panels are kept, others are routinely discarded.

Rippling ever so slightly, the large canvas-sized sheets hang freely like oriental scrolls. Unfettered by a mat, the sheets reflect and refract light and assume an enigmatic vitality that endows the works with a dimensional quality. Although seemingly fragile, the large resin-coated sheets are sufficiently resilient to withstand the rigorous processing and handling necessary for Rankaitis to achieve her results.

Scale is a critical element for Rankaitis, who finds that a six- or seven-foot sheet the minimal area with which she can comfortably work. The necessity for the large format comes from the customary canvas scale for which seven feet is not oversized. The sole exception to the large format are the small detail studies on twenty-by-twenty-four-inch sheets executed preparatory to the larger works. *Tail*, 1983 (fig. 2), from the Flight Plan series, is one of these small works. Understandably, the monumental monoprints differ substantially from the small sketches, which appear more as fragments and less as diminutive versions.

The aeronautical iconography first apeared in 1979 and since 1982 has come to occupy Rankaitis almost exclusively. The origin of this imagery is found within the vicinity of her studio, near the flight path of the Los Angeles International Airport. From her windows, constant, repetitious views are afforded of jets lilting across the horizon. For Rankaitis the planes are paradoxical: of enormous mass, they possess a surprising lightness. Flight is also one of the technological enigmas of modern life, something of a scientific mystery to the layman. Additionally, Rankaitis saw that the surfaces of her prints were allied to the metallic exteriors of the planes.

*Wing*, 1982 (pl. 3), another pivotal work, links earlier prints from the Fire River series, with their profuse detail, to the subsequent, more gestural, and expansive pieces. Predominant, deep fuscous tones obscure the detail that is quite apparent in reproduction. Rich blacks, punctuated by passages of whites, create a mysterious aura. Excerpts of the bomber tail, that frequent motif of Rankaitis, are discernible. Through the murky washes of earthy tones, a complex, yet subtle montage of translucent forms emerges.

Rankaitis builds dense passages incorporating imagery derived in various ways. Photograms, contact prints, projec-

tions, and enlarged, multiple-generation negatives are all montaged within the emulsion. There is no appearance of surface buildup or manipulation to mar the pristine sheen of the photographic emulsion. The precise bilateral division of the sheet suggests the subsequent diptychs, although at this time Rankaitis was disinclined to move away from one panel. A significant loosening of the composition is exhibited in *Wing*, adumbrating the more expansive, energetic approach of later prints. *Wing* evinces the gradual shift to a more painterly emphasis with the photographic images rendered in an increasingly abstract fashion.

A signature element in Rankaitis's prints are the chromatic striations, appearing somewhat more pronounced in reproduction than in the works themselves. In the earlier prints they functioned largely in a structural manner. By 1983 Rankaitis began to utilize the bands in a vigorous way to enhance movement. For example, although in *Grey Ghost*, 1983 (pl. 6), there are both horizontal and diagonal layers, it is the latter that are strongest. The ability of the montage of photographic images to suggest motion is palpable. Upward streaks carry the picture of a bomber fuselage and reiterate the form (the cockpit is visually alliterated three times). But it is the isolated wheel in the center, with its appearance of motion, which captures our attention. Here Rankaitis clearly refers to the futurist fascination with motion and the machine. Through these gestural strokes Rankaitis suggests soaring movement and dramatic force. Roseate washes alternate with refulgent golds to underscore the vitality of the images shearing across the sheet. The brooding, somber tone of *Wing* and the earlier works has been replaced by a lighter, airier atmosphere that contributes to a vivid galvanism.

Rankaitis often presents a puzzling, recombinant depiction of aircraft, testifying to her disinterest in any sort of reportorial description of these machines. The four wheels of an Eastern Airlines plane in *Flight Plan (Perloff Variation)*, 1983 (pl. 4), result from a conflation of negatives to produce a startling new image. The second plane, slightly higher, bearing the legend "US MAIL," is so thoroughly abstracted that it conveys the speed of flight more readily than an identification of aircraft. Spear-shaped bands of light and color carry the planes forward against the blank, gleaming, golden background, further abstracting and rendering the objects icon-

ically. The simple sky, relatively open and unaffected, directs the eye to the planes with their contrail streaks.

From the same period, rather similar in scale and golden hue, is *Rain/Slide*, 1983 (pl. 5). A complex montage of images, here jet tails, produces an abstraction with strong formal elements. Pale, painterly blue streaks propound the idea of a vessel passing along the runway. The double-tail adds to the stop-motion effect. The interplay between painting and photography is evident, and only the barest remnants of negatives remain.

One of the largest and most striking works is a towering nine-and-a-half-foot-high diptych, *Prolate Habitat*, 1983 (pl. 7). The two dissimilar panels, each forty-two inches wide, strangely function very well together, even though the left sheet is a dark, black shroud with only minute photographic detail. Conversely, the right is emblazoned with a trio of familiar bomber tails (with the portion of a fourth faintly visible at the top). Emphatically joining the two, is a single reddish band carrying the eye from the more active right panel left into the black abyss.

The right sheet reads cinematically as the eye scans upward moving frame by frame (fig. 3). The three tails are presented in slight variation, although the basic formal elements predominate, balancing the massive black areas on the left. In this motif can be appreciated Rankaitis's reverence for minimalism. No longer relegated to the background, the radiant gold streams across the image to increase the transparency of the image and obliterate background details. Photograms of opaque negatives dance across the top of the left panel, while lower in the panel are contact-printed images of jet planes soaring overhead. The deep darkness of the left panel contributes an additional psychological note, hinting that the tail may well be an emblem of warfare. The angularity of the elements and repetition of the blacks further suggest the possible dark nature of the object. This too is part of the dichotomy addressed by Rankaitis. Although her works are not political, she nonetheless acknowledges that these elegant planes are not without destructive potential. Lacking some of the lyricism of earlier works, *Prolate Habitat* gains a strong staccato effect by the reuse of the tail image. The luminous mystery of the rich black pools is evident only upon confrontation with the actual piece. Nevertheless, *Prolate Habitat* achieves a

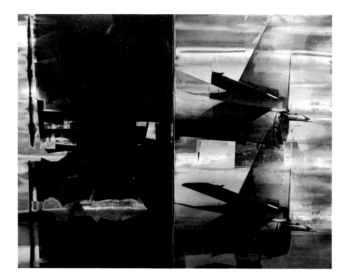

Fig. 3.   *Prolate Habitat* (detail), 1983.

powerful visual presence by its simplicity.

In the late spring of 1983 in an effort to gain more latitude over the long, narrow format, Rankaitis began to use fifty-six-inch-wide paper with a mat finish. Accordingly, the high reflectiveness of *Prolate Habitat, Rain/Slide, Wing*, and other works was eliminated, and the pieces became easier to view and a bit more open, as in *Grey Ghost*. The striking luminosity of the earlier prints and tight detailing of the Fire River series were now totally supplanted by works with an increasingly gestural, painterly approach and larger, more interactive fields of images.

By far the largest and most complex piece is *RR Voor RF*, 1983 (pl. 8).[7] This incredibly intricate triptych was produced in a relatively short period during the summer of 1983. Its enormous size, fourteen feet wide and just under nine feet high, likens it to painting models (fig. 4). In *RR Voor RF* Rankaitis makes clear use of military jets as subject matter. The work is rather monochromatic, comprising a blend of copper, gray, and silver with exceptionally rich blacks. Pronounced diagonal striations link the three panels and establish an underlying tension for the overlay of translucent images of planes that run across the triptych. The whole is so thoroughly interrelated that only parts of planes can be discerned. In this large work Rankaitis confronts the paradox

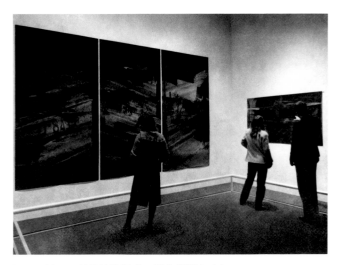

Fig. 4.    *RR Voor RF*, 1983 (left); *Rain/Slide*, 1983 (right).

of her subject, at once breathtaking technological achievements of amazing beauty and instruments of war.

Unlike the more subdued diptych *Prolate Habitat, RR Voor RF* carries images across the panels. The use of planes jutting out at diagonals reinforces the dynamism. Abstraction and formal concerns again dominate the photographic components. Here Rankaitis pointedly reveals, however, the importance of content as well. In *RR Voor RF* Rankaitis demonstrates her ability to forge a monumental work that expands the scale of photography. She maintains an intricate balance of all elements to contribute to the dynamism of the work. The complexity and interaction of the components are well orchestrated, with certain details reiterated. *RR Voor RF* presents a marked shift from the more abstracted works preceding it.

Reflecting her painting background, Rankaitis is concerned with the experimental expansion of photography in terms of scale, process, and imagery. Intrigued with the potential of photographic materials, she works entirely within the photographic emulsions and does not build up paint on the surface. In her monumental, unique pieces she employs the photographic image in an abstract, formal manner. By interrelating painterly areas of metallic color and loose recombinations of images, Rankaitis achieves a special dynamic brilliance. Although not presented in a literal manner, content is never eclipsed by the strong abstraction of these works. Her series on flight is very much a product of the times, honoring the technological achievements and symbolic significance of these airborne machines. Working with the unknown, Rankaitis tests the boundaries of materials, imagery, light and scale. She is interested in the threshold between the animate and inanimate. Ongoing experimentation continues as it has for the past six years to be a fundamental premise of her work.

NOTES

1.   László Moholy-Nagy, "From Pigment to Light," in *Photographers on Photography,* ed. Nathan Lyons (New York: Prentice-Hall, Inc. 1966), p. 74.

2.   Ibid., p. 77.

3.   See Franz Roh, "Mechanism and Expression," in *Classic Essays on Photography,* ed. Alan Trachtenberg (New Haven, Conn.: Leete's Island Books), p. 160.

4.   The Fire River series was a direct result of a disastrous fire in which much of her early work was destroyed. After the fire Rankaitis felt free to adopt a wholly new approach to photographic materials.

5.   Smaller, twenty-by-twenty-four-inch works from 1979 and 1980 include this imagery, but it was not yet used thematically before *Lake*.

6.   Moholy-Nagy, p. 80.

7.   The title *RR Voor RF* is dedicated to Rankaitis's husband, Robbert Flick. It is one of two named pieces.

PLATE 1

Susan Rankaitis, *Gold/Water*, 1980

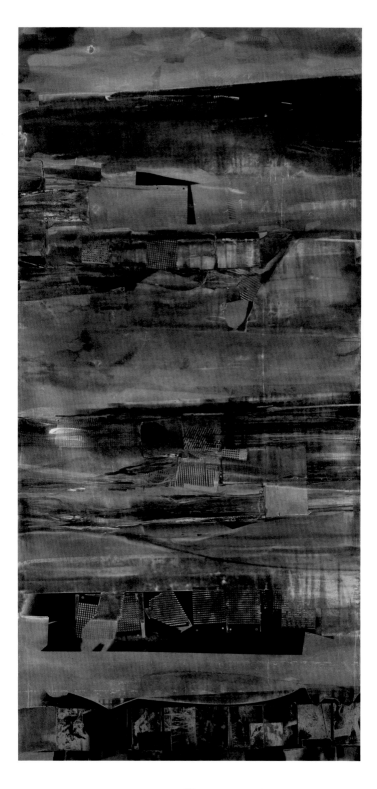

PLATE 2

Susan Rankaitis, *Lake*, 1980

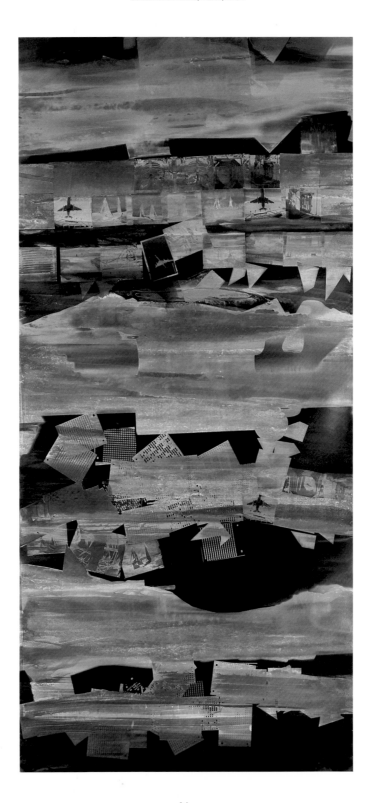

Susan Rankaitis, *Wing*, 1982

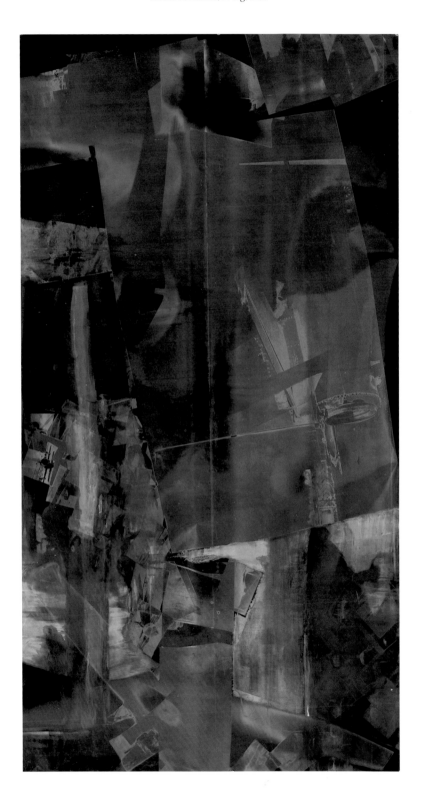

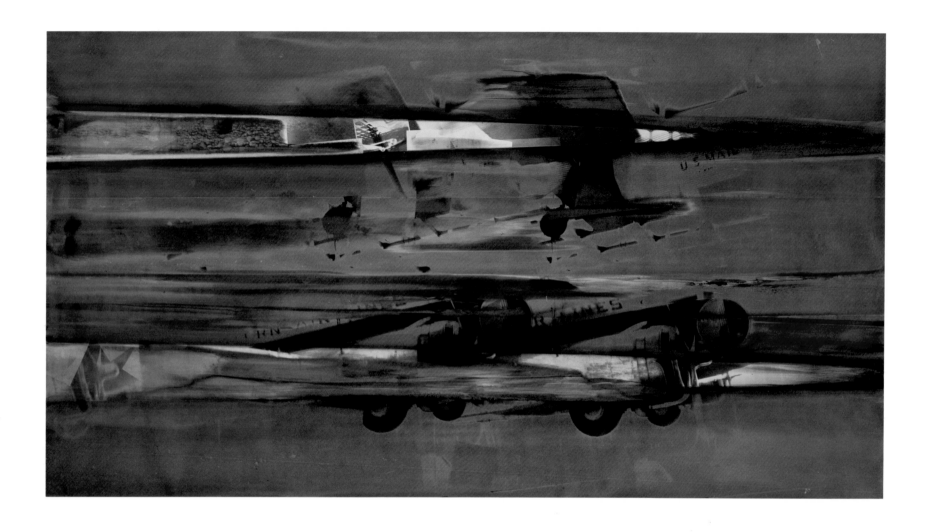

PLATE 4

Susan Rankaitis, *Flight Plan*
*(Perloff Variation)*, 1983

18

PLATE 5

Susan Rankaitis, *Rain/Slide*, 1983

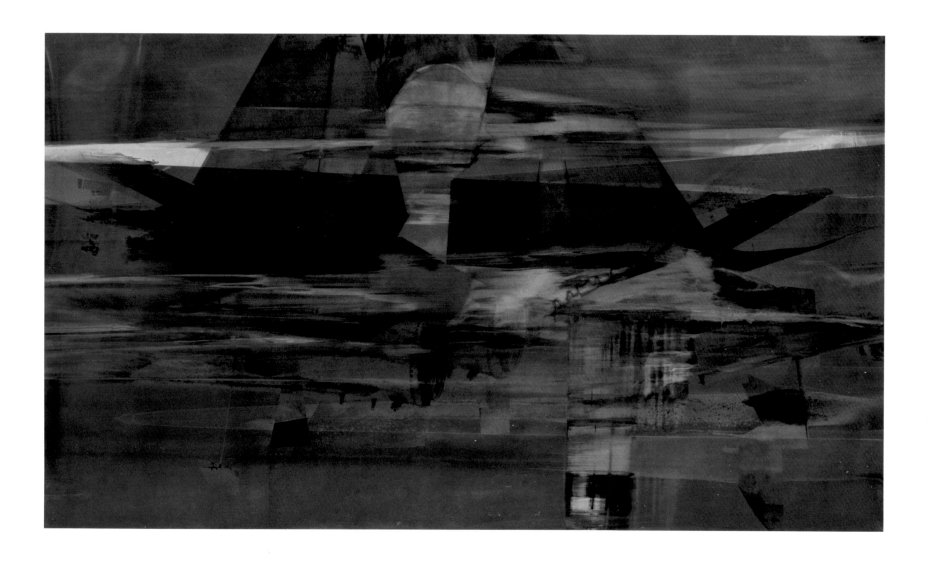

PLATE 6

Susan Rankaitis, *Grey Ghost*, 1983

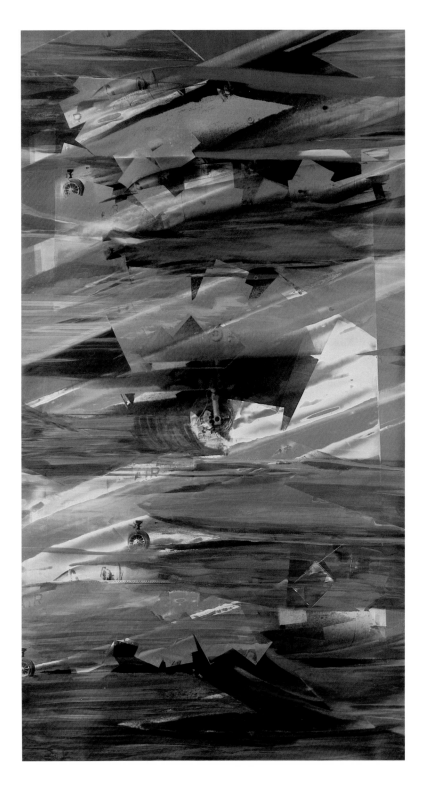

PLATE 7

Susan Rankaitis, *Prolate Habitat*, 1983

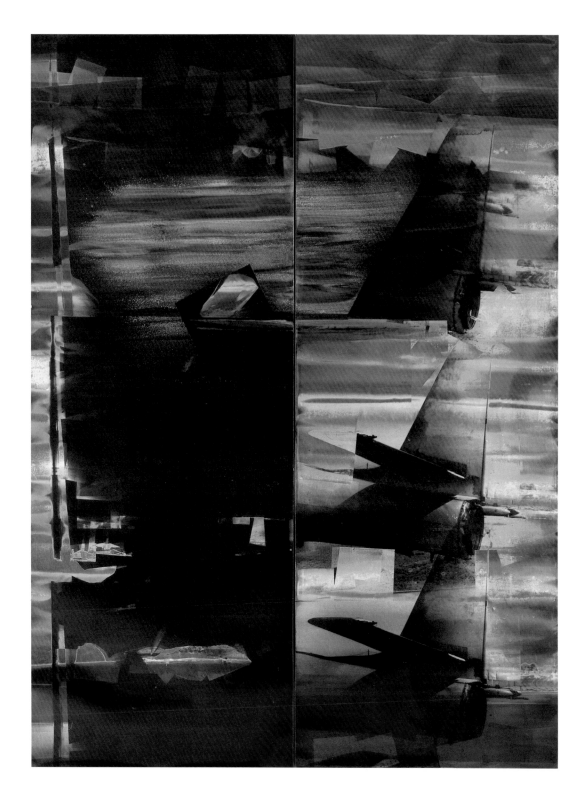

PLATE 8

Susan Rankaitis, *RR Voor RF*, 1983

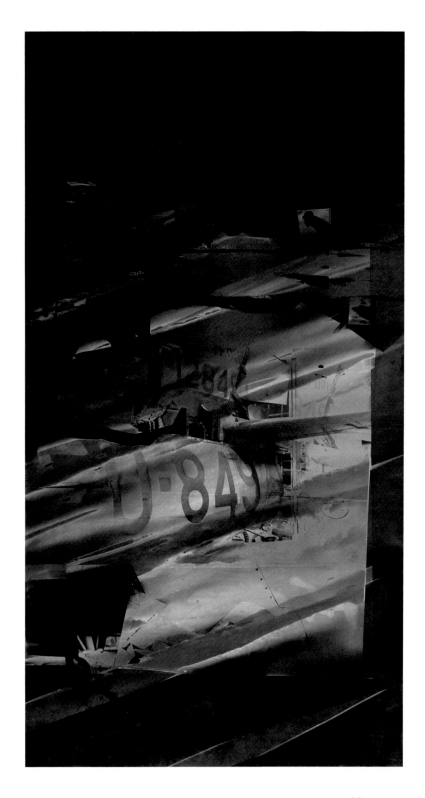
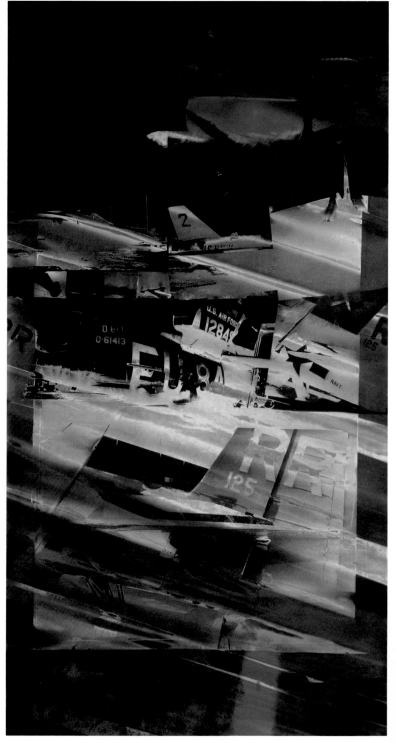

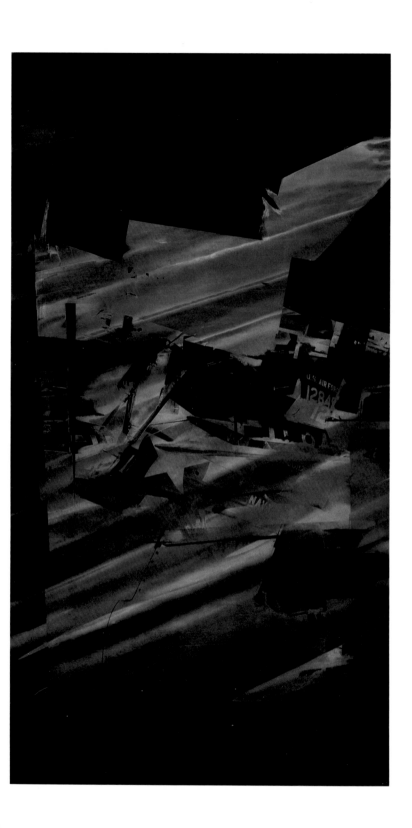

PLATE 9

Susan Rankaitis, *L'avion, L'avion*, 1983

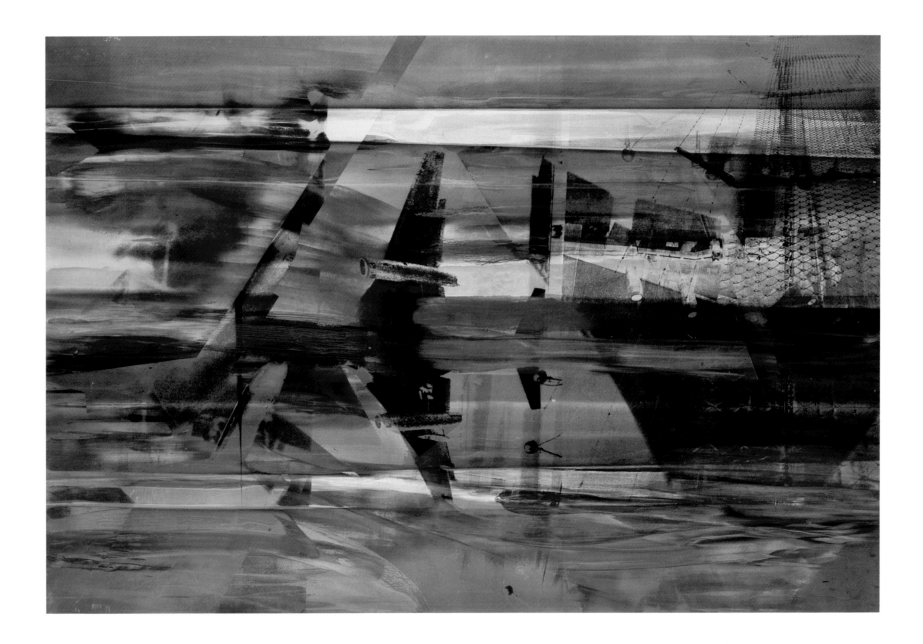

# Richard Misrach

The current desert series of Richard Misrach is his most extensive and ambitious effort, representing a substantial departure from preceding series. Abandoning the flash and mysterious night setting, Misrach has adopted a more literal, classic stance toward his subject, the desert terrain of the Coachella Valley region. The square, 2¼-inch format and wide-angle lens used by Misrach until 1980 is now replaced by the eight-by-ten-inch camera and normal lens, signaling a concommittant change in addressing the subject.[1]

These prints are a shift from the earlier desert photographs. The dark, exotic selenium-toned prints give way to color, and night has shifted to day. Indeed, the differences between the two groups are profound, and it is only the desert that is shared. *Yucca, Baja California*, 1976 (fig. 1), typifies the manner previously employed by Misrach. In this work the long exposure, dark staging punctuated by brilliant strobing, iconic positioning of the subject, and eerie, romantic atmosphere are combined with a consistent centrality of form and massing.

His current straightforward, classical approach to the landscape yields works thoroughly unlike the mysterious, spiritual images of the mid-seventies.[2] Sumptuous detail and bold massing are now subordinated to long views of mostly barren space, as in *St. Jack*, 1981 (fig. 2). The fundamental structure of the new desert photographs with their empty frames is unprecedented in any of his earlier series. Misrach continues to make large, thirty-by-forty-inch prints; the scale functions especially well not merely because of the larger negative but also because of the closer affinity to the vastness of the subject.

In 1979 Misrach returned to the area around Palm Springs, California, without express plans to photograph there, after working intensely during 1978 and 1979, first in Hawaii and then in Louisiana, Greece, and Rome. The contrast of subject between the lushness of his earlier suites and newly rediscovered desert terrain provoked Misrach to examine the aesthetics of that often overlooked location. Varying considerably from the commonly accepted image of the American desert, the region of the Coachella Valley lacks the drama of the Mojave or Death Valley or the awesome majesty of the Grand Canyon. Virtually all the photographs in this group were made in southeastern California. Misrach purposefully decided to focus critically on this region and examine the entirety, the parts and their relationship, and the ever-changing environment. He limited his work to the Coachella Valley, finding it a region with sufficient diversity of terrain, land usage, and cultural impact to require his attention for a protracted period. Light and climactic shift create a particularly strong effect on the region, whose subtle beauty especially intrigued Misrach. The atmospheric influence of the Pacific Ocean to the west, separated from the far hotter desert climate by a wall of mountains, may perhaps cause in part the highly changeable atmosphere at that mountainous juncture.

While slowly adopting a new format and scale, Misrach began to realize that long, far views were kindred to vast, empty spaces. Working much more slowly with the large camera, gradually pulling further and further back, Misrach became more methodical and precise, attending to many

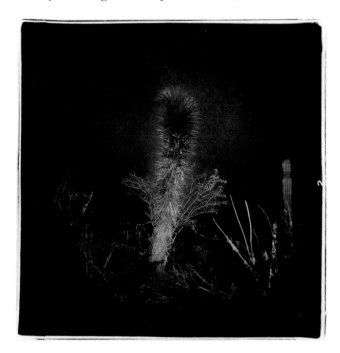

Fig. 1.  *Yucca, Baja California*, 1976; selenium-toned gelatin silver print; 19½ x 16 in., sheet. Los Angeles County Museum of Art; M.85.5.1.

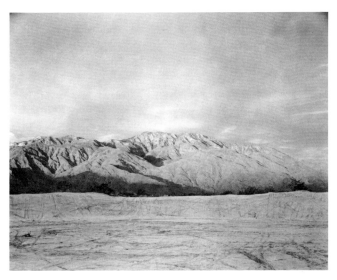

Fig. 2. *St. Jack*, 1981.

details, such as the remarkable atmospheric effects of light on the land, which he had previously ignored. He found that much of the region had been relegated to an insignificant status as a wasteland on the road to somewhere else. Misrach was challenged by the prosaic, barren subject, which would test his use of the color medium.

In February 1982 a fire destroyed thousands of his negatives, including about three thousand documenting the desert project and a considerable amount of earlier work. Only contact prints of the new series were salvaged. Although years of work were lost, Misrach decided to begin again the desert series, concentrating exclusively on the desert landscape.[3] As he began to explore the region, the necessity for an exhaustive examination of the region, one that went beyond mere visual elements or issues of color to reveal the multifarious appearances of the desert, was revalidated.

In the course of making thousands of images, Misrach began to perceive that a number of separate subgroups were emerging and expanding in his series. Although fundamentally interconnected on certain levels, ten large sections identified as cantos were quite distinct. These are the Highway, Terrain, Space, Scale, Light and Color, Inhabitants, Visitors, Survival, Human Artifact, and Return to Wasteland. They give some structure to the overall series, articulating

Misrach's primary theoretical and topical interests. The cantos allow the photographs to "progress from the descriptive and the informative to a metaphorical resolution."[4]

At once paradoxical and appropriate, the first canto is the Highway. Although scarcely the logical, initial motif of the desert, it is nevertheless important, for it is the access, the means of entering the domain. Misrach does not view his subject pejoratively. He chooses instead to record the land as he finds it, with equanimity and objectivity. For him the road is a ubiquitous and necessary element of our mobile culture. It may affect the desert but will scarcely subdue it. Furthermore, our appreciation of the wilderness, ironically, is made possible by this network of highways and roads.

The road as an integral part of the landscape today appears in several photographs. Perhaps most striking in *Edom Hill Road*, 1983 (pl. 14), the road streaks around a hill in the background, winds into the foreground, and moves out of the frame. Quite literally a lighted road, it brilliantly reflects the sunlight that in turn transforms it from a mundane surface into a shining pathway. It is precisely this remarkable transitory quality that Misrach refers to when describing the "special configuration of light, landscape, and events" that charges certain images, giving them a vitality or complexity. Here, the lights and darks of the scrubby vegetation and soil blend with the shading of the eroded hills to form an earthy palette at odds with the intense, albeit delicate, tonality of the blue-purple sky. The photograph's astonishing clarity discloses a rich profusion of details, and the land and road are described with an elegant harmony. The intense coloration of *Edom Hill Road* is a product of shifting desert light and contrasts with the bright, hazy atmosphere seen in other photographs, such as *Dune Buggy Tracks and St. Jack*. Furthermore, Misrach notes that the photographic medium creates the illusion of fact. The photographic moment challenges the continuous experience of time, place, and event by suspending time. Any distortion by materials and equipment is eclipsed by the validity of the photograph as the faithful witness.[5]

In *Palms to Pines Highway*, 1983 (pl. 11), the rugged, parched terrain manifests a palpable tactility. Providing some reference to scale, a sliver of road cuts through the crusty, inhospitable hills. The monochromatic composition is almost

wholly abstract, inviting close scrutiny. Misrach's camera confounds the eye by revealing the minute detail of the remote background. Totally submerged within the overall composition, single details are dwarfed by massive shadows and surging outcroppings. The tight range of dour tones illustrates Misrach's interest in the subtle appearance of color as an exponent of light. This view, however, offers none of the atmospheric qualities typical of the series.

The wealth of textural surface detail sharply contrasts with other works, such as *Salton Sea Overview,* 1983, a soft, lyrical, atmospheric view in which sky and water blend. The Salton Sea group offers another referent to the desert, for along the somnolent shore are remnants of trailer camps and other settlements despoiling the remarkable area. *Clothesline, Salton Sea,* 1983 (pl. 16), is similar in lighting, coloration, and mood to *Overview.* The placid waters of the Salton Sea are extraordinarily flat, virtually mirroring the sky. Only the barest of inexplicable details are provided. After close examination, the two T shapes standing up out of the lake and their watery reflections reveal themselves to be clothesline posts, at once altering an otherwise eloquent view.

The desert, Misrach observes, preserves cultural flotsam and jetsam far better than less arid regions. Only slowly decaying, these remnants linger on to become part of the present landscape. In this observance, Misrach suggests a concordance with the writings of J. B. Jackson. For Misrach the wilderness is a rarified condition of the American landscape, and it is, therefore, unrealistic to expect a panorama without some vestige of man. The intentional inclusion or exclusion of artifacts is a forced visual scheme, for these things are now bona fide components of the landscape. So ubiquitous is man's presence that the issue of intrusion into the sacred land is no longer sufficiently valid. Good or bad, cultural artifacts are a legitimate element of the landscape. It is, he observes, not paradise lost but paradise changed.[6]

In *Diving Board, Salton Sea,* 1983 (pl. 17), are revealed the tattered edges of an altered paradise. The salty shores are depicted with subtle luminosity. The stark, horizontal arrangement echoes a still and haunting emptiness, unrelieved by the even light. The forlorn, abandoned pool and its surroundings stand as archaeological relics for future investigations.

The chief influences for the desert photographs stem not from visual sources but from two books: *Scenes in America Deserta,* 1982, by Reyner Banham, and *The Desert,* 1901, by John C. Van Dyke. The correspondence between the authors' perceptions of the properties of the arid landscape and Misrach's reinforced and expanded his understanding of the land. Van Dyke spent three years rambling through the same region explored by Misrach. He was among the first to rhapsodize about the surprising visual wealth of the mutable desert wasteland, an insight antipodal to the nineteenth-century appreciation of the hallowed, pastoral vista. Misrach's cantos correspond to certain sections of Van Dyke's book. Illusions were a phenomena that Van Dyke also observed in the desert.

Van Dyke saw the dramatically changing colors of the desert as a function of light and the daily atmospheric cycle. The cool dawn is replaced by a fiery furnace with bands of heat waves by midday and an attendant change in sunlight. He noted that particles in the dusty air may appear yellow, blue, or even pink, just as Misrach observed in *San Gorgonio Pass,* 1981 (pl. 12). Van Dyke too was fascinated with the sea. Minimal details and simple masses of form and color are paramount in both. Lacking the charms of a bucolic setting, the desert nonetheless is sublime in its lonely desolation. Van

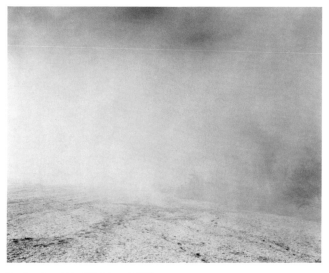

Fig. 3. *Desert Fire #19 (Mecca),* 1983.

Dyke wrote about certain visual phenomena of particular interest to a photographer. Distances, whether one judges the nearness of things or their remoteness, are entirely deceptive in the desert. Furthermore, perspective becomes erratic, with an abnormal foreshortening that either flattens or telescopes the planes. Although aware of efforts to cultivate the desert, Van Dyke appreciated as a stronger power the relentless force of nature to regain its dominion and return the desert to wasteland.[7]

It is light rather than color that occupies the attention of Misrach in these images.[8] For him the changeable light is paramount, for it is the light that reveals the different appearances of the desert landscape. Moreover, both Banham and Van Dyke discussed the pivotal role of light in creating an array of colors. Nevertheless, his works exhibit color in hues both intense and diluted. One of the very few images taken outside the Coachella Valley is *Painted Desert, Morning Light,* 1982 (pl. 10), in which is illustrated a startling display of unusual desert color. The view is organized around a remarkably spare composition, with the sky and ground reduced to formal washes of color. Yet it was the chromatic effects of changing light and not pure color alone that drew Misrach to the scene.

As with some of the previous desert images, this photograph demonstrates Misrach's interest in the special equilibrium between ground and sky. A strong sense of abstraction is evident in the empty plane. Vacant, atmospheric images, such as *Desert Fire #19 (Mecca)*, 1983 (fig. 3), continue the ground-sky inquiry. Color is almost nonexistent in this view, with details and sky obscured by opaque clouds of smoke. The frame is disconcertingly barren, just as a photograph taken in a dense fog would be. More than a formal exercise in minimalism, the photograph records subjectively an event concerning the inexorable cycle of change that is part of the desert landscape.

In *Dune Buggy Tracks and St. Jack,* 1982 (pl. 18), the powerful, midday sun in the torrid desert has reduced the terrain to complex, varying shades of off-white. The lack of color, spartan composition, and tracks in the foreground call to mind the arid black-and-white views of Robert Adams. The senseless, recreational erosion of the desert is, like the highways and changing light, part of the desert today. Misrach offers the view in a quiet and direct manner without polemics.

As with the Mecca fire, it is the diaphanous light and nearly imperceptible range of color that attracted Misrach. Unexpectedly, the sfumato atmosphere does not romanticize the work. The abstraction of the large print and atmosphere and texture of the terrain are too literally rendered to be melodramatic. While all his views are uninhabited, their clarity abrogates any illusion to the past. The precise details and composition suspend the present and not the lost past.

The desert fire is another metaphor for the changing environment. Misrach's desert-fire group began with *Desert Fire #1 (Burning Palms)*, 1983 (pl. 19), an image more complex than might be first supposed. The photograph is a fact but also something very much of an illusion. For regardless of the actual scale of the print, the charred palm trunks consistently read as diminutive models rather than towering palm trees. The gross disparity in scale between the foreground and the hillock in the midground is a photographic ambiguity, belying the multistoried height of the palms. Seemingly at the end of its destruction, the flames are localized on the last palms that have burst into a torch. The vivid yellow orange is the most strident of Misrach's colors, sharply constrasting with the muted tones of many of his other prints. The constantly changing environment, eternal desert wasteland, and destructiveness of nature as part of the larger cycle of evolution are themes directly referred to in this image.

Divergent color as a manifestation of light and atmospheric change is disclosed in two dissimilar photographs. In *San Jacinto Mountains with Storm Clouds,* 1982 (pl. 13), tumultuous light and dark clouds dominate the top half of the frame. The dramatic sky is very much unlike other representations of sky and air in his desert group. Clouds press down on the land, allowing only a narrow strip of mountains at the point where they meet the flatter plain. *Storm Clouds* is an emotionally charged view, with a dark, moody palette that captures the changeable appearance of desert light.

In marked contrast is the uncomplicated openness of *San Gorgonio Pass,* 1981 (pl. 12). Here the potential of the large-format camera is fully apparent in the sharp clarity of details. Dark bushes dot the landscape in staccato effect. The pointillist stubble against the white ground crisply divides the image. Above the far-distant, even horizon is a mountain range disconcertingly awash in a faint pink light. The light purplish

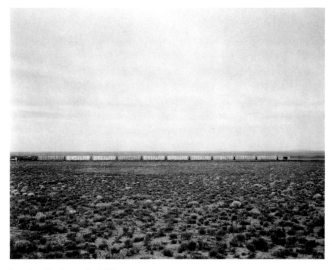

Fig. 4.   *The Santa Fe*, 1982.

NOTES

1.   The effect of format change noted by Misrach has also been identified by Joe Deal who similarly shifted from the square format.

2.   See Irene Borger, "Stopping the World: Photographs as Myths," *Exposure* 17, no. 3 (Fall 1979): 22.

3.   Although identified in his cantos, Misrach's portraits of the residents of the region were abandoned following the 1982 fire. These images exist only as eight-by-ten-inch contact prints.

4.   Richard Misrach, interview with author, December 1984; see also Richard Misrach, "The Illusion of Fact," *Aperture* 98 (Spring 1985): 16.

5.   Misrach, p. 16.

6.   Unlike Robert Adams or others who find the western wilderness to be lost, despoiled by developers, residents, tourists, and industry, Misrach sees the landscape as naturally being in a state of flux.

7.   John Van Dyke, *The Desert* (1901; reprint, Salt Lake City: Peregrine Smith, 1980).

8.   Richard Misrach, interview with author, December 1984.

9.   Reyner Banham, *Scenes in America Deserta* (Salt Lake City: Peregrine Smith, 1982), p. 222.

10.   Richard Misrach, interview with author, December 1984.

shadows and soft pink light have a disquieting unnaturalness. Yet this pinkish coloration is precisely that which Banham and Van Dyke both fervently asserted about the desert.[9] As a thirty-by-forty-inch print, the image is like a window opening out into the valley. The scale is so expansive that even the telephone poles are reduced to minute markings and the highway becomes but a hairline. The supremacy of the desert over man is unquestionable, and the advances of culture appear as mere insignificant details.

Of special meaning to Misrach is *The Santa Fe*, 1982 (fig. 4), a unique configuration of space, light, and events. A highly formalized balance is established between the nubby ground and smooth, blue sky, both neatly cordoned off along the horizon by red and white boxcars. The most reductive, minimal composition is captured. The train rolls along just perceptibly below the horizon, bisecting the frame into two horizontal registers. Yet, this is another illusion, for the train is in fact standing still.[10]

PLATE 10

Richard Misrach, *Painted Desert,*
*Morning Light*, 1982

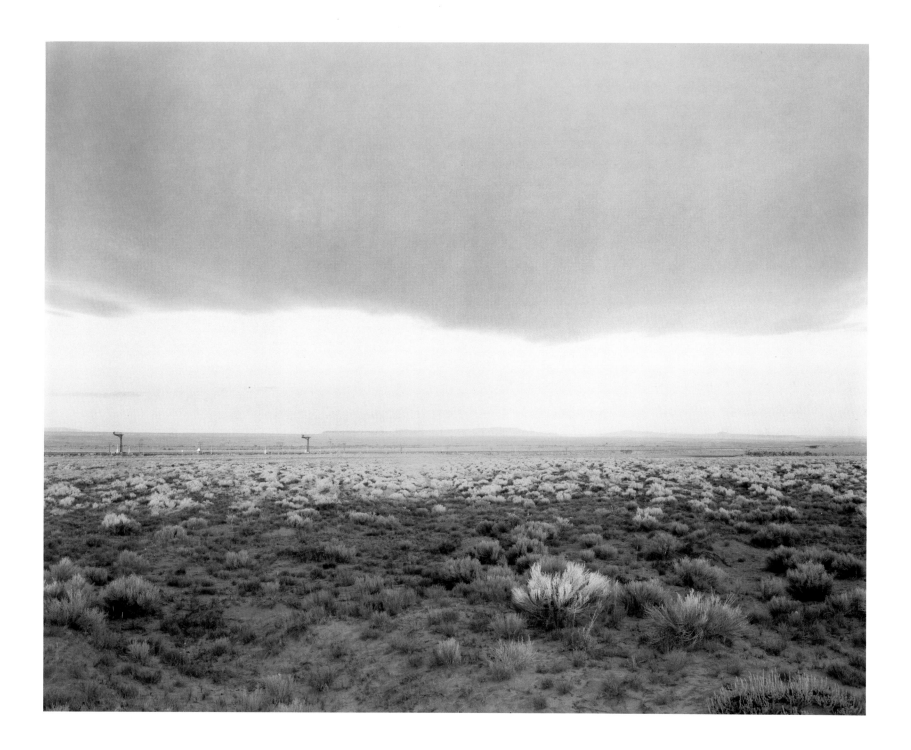

PLATE 11

Richard Misrach, *Palms to Pines
Highway*, 1983

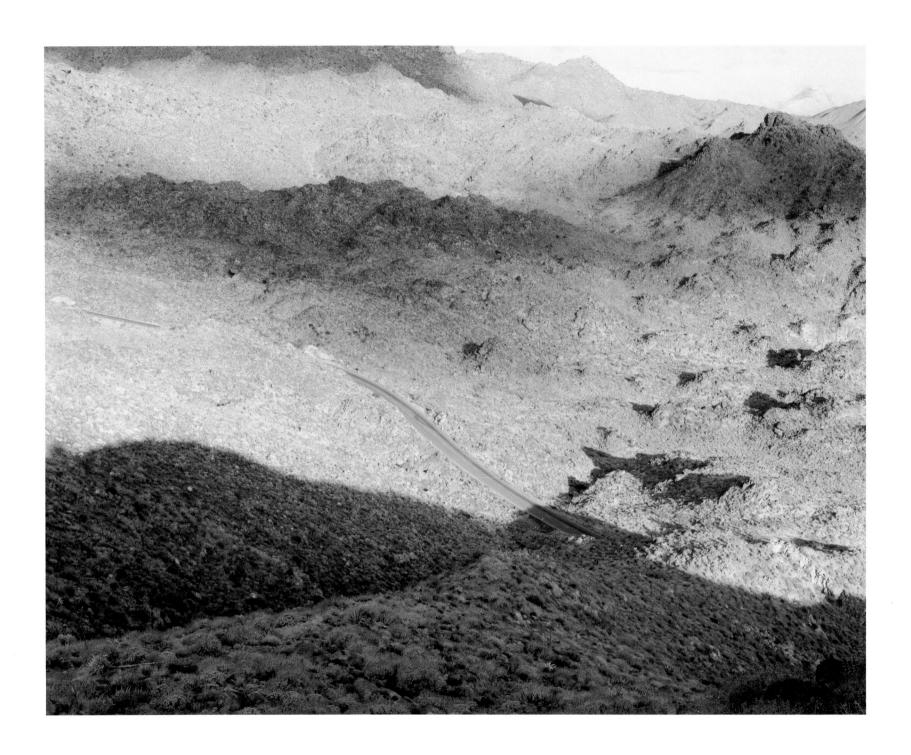

PLATE 12
Richard Misrach, *San Gorgonio Pass*, 1981

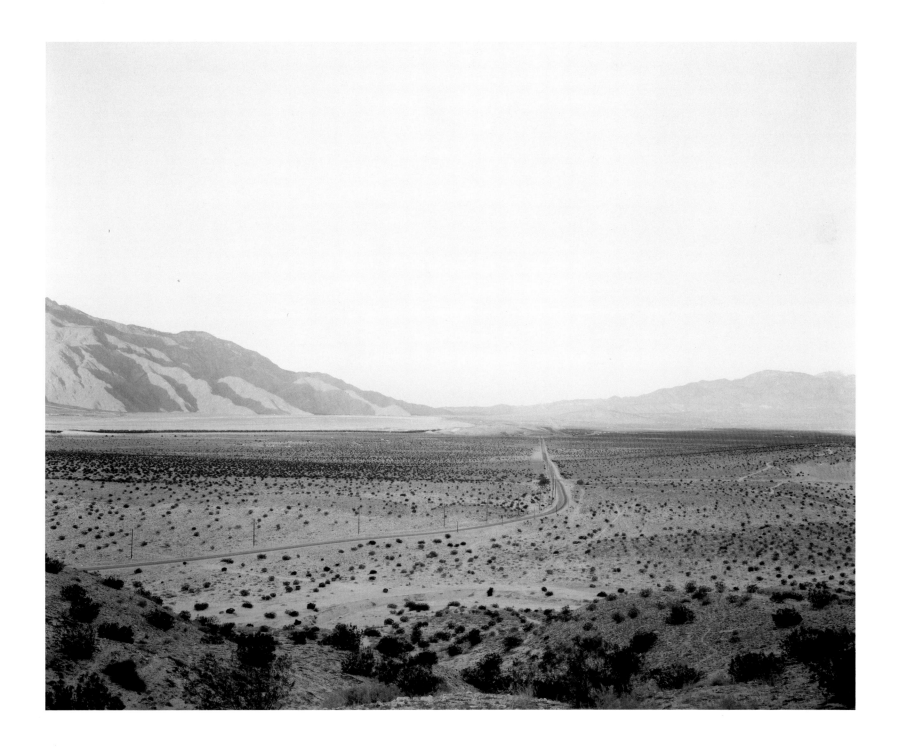

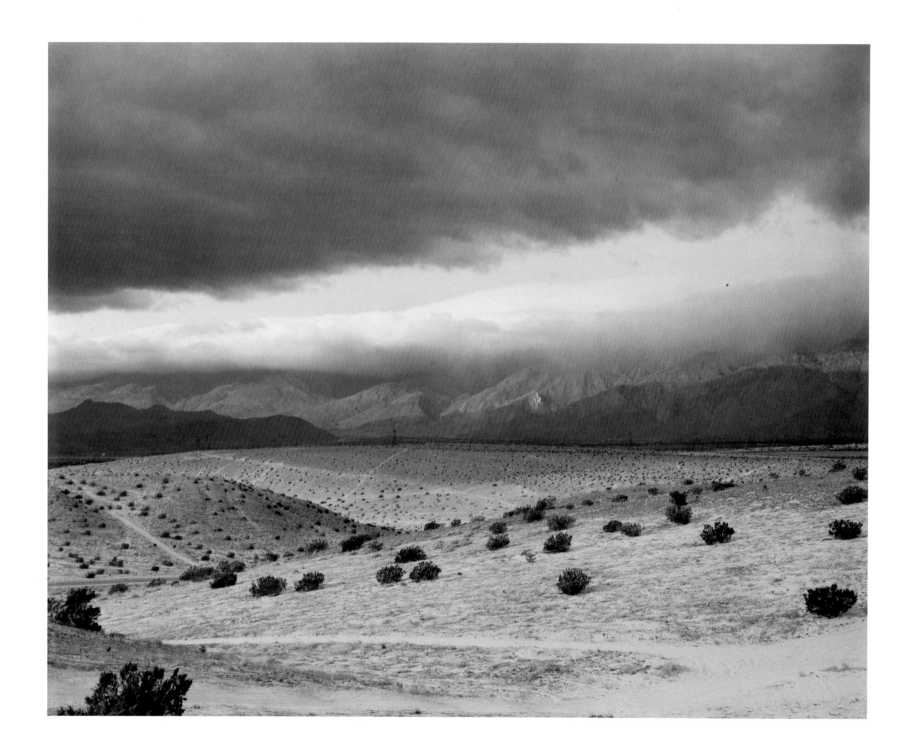

PLATE 14

Richard Misrach, *Edom Hill Road*, 1983

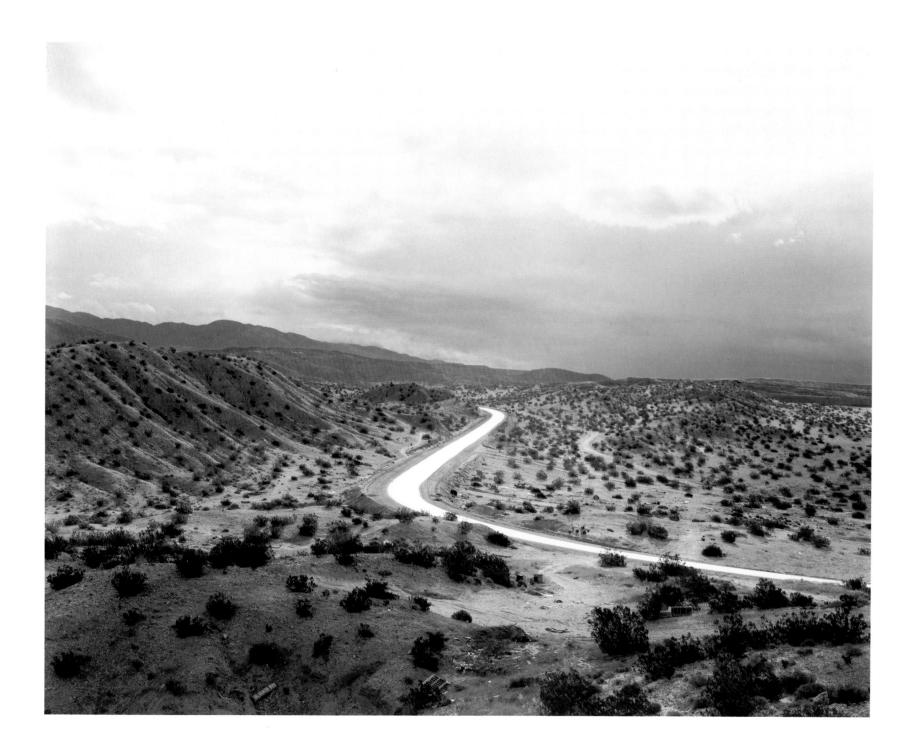

PLATE 15

Richard Misrach, *Foot of St. Jack #1*, 1982

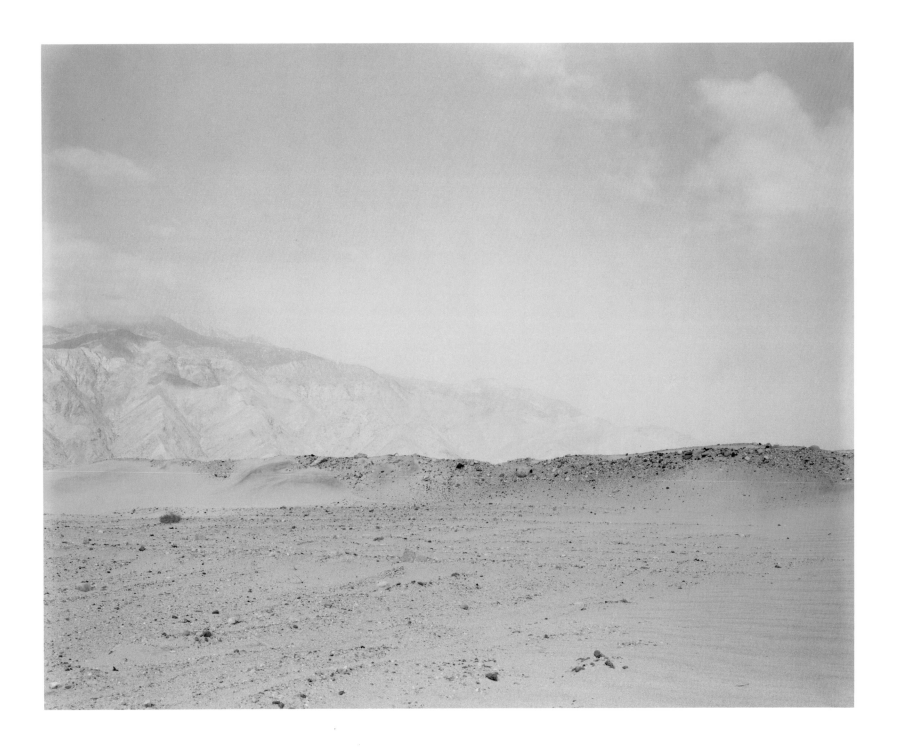

PLATE 16

Richard Misrach, *Clothesline, Salton Sea*, 1983

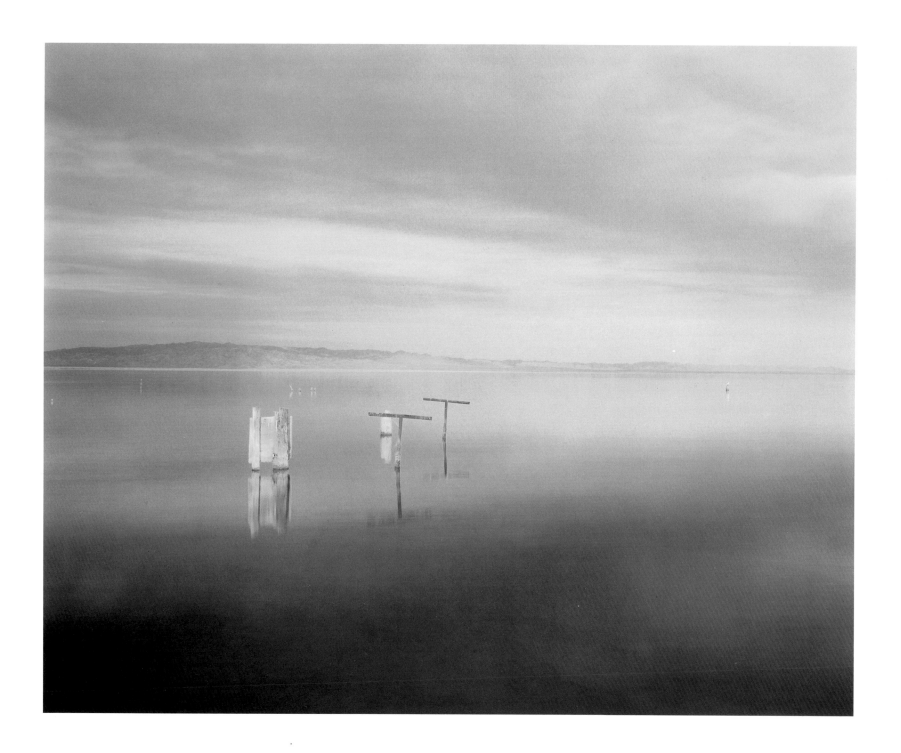

PLATE 17

Richard Misrach, *Diving Board,*
*Salton Sea,* 1983

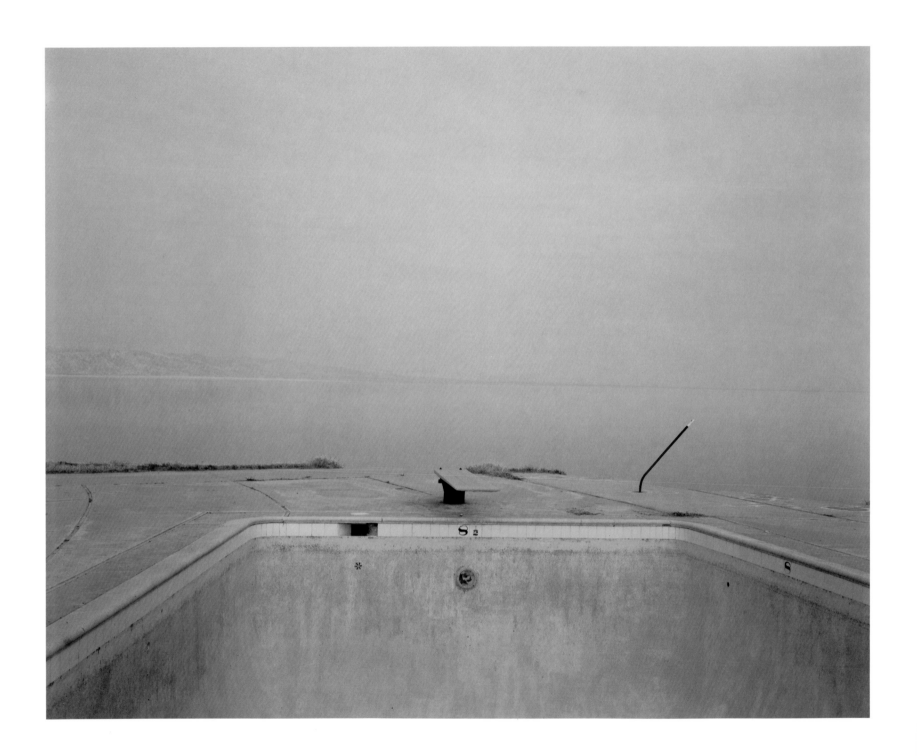

PLATE 18

Richard Misrach, *Dune Buggy Tracks*
*and St. Jack*, 1982

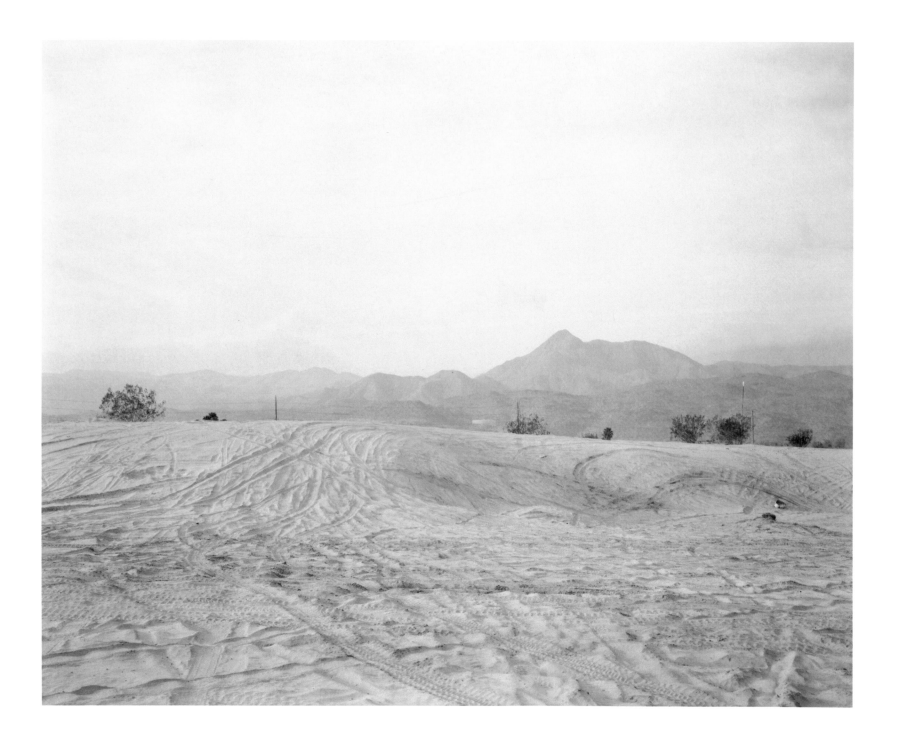

PLATE 19

Richard Misrach, *Desert Fire #1*
*(Burning Palms)*, 1983

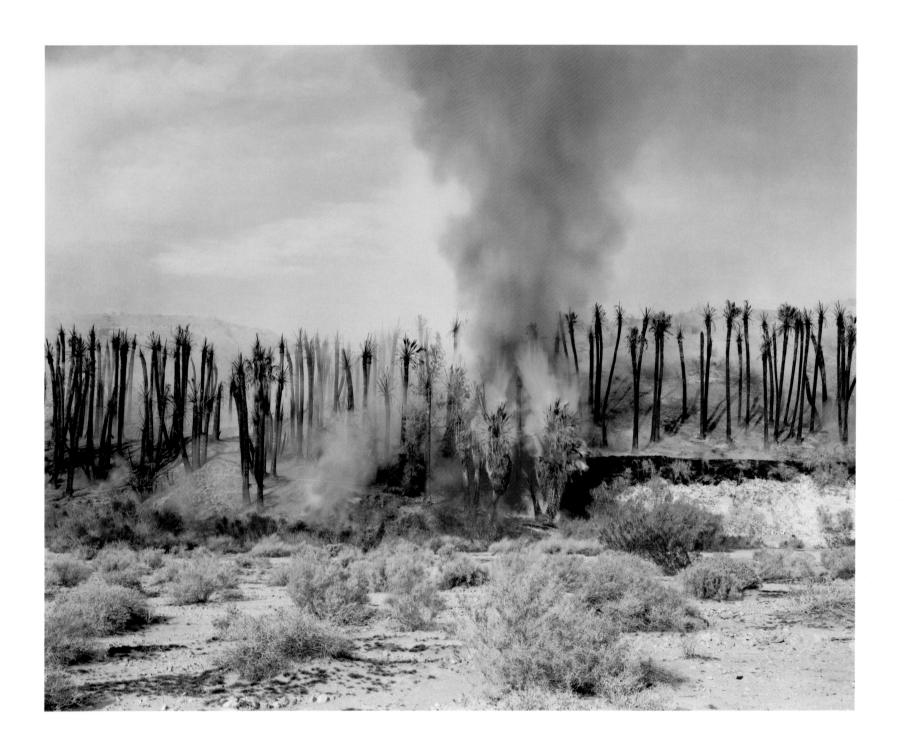

# Mark Klett

The work of numerous contemporary photographers bears witness to the legacy of nineteenth-century survey expeditions during which the western territories were first recorded on film. These landmark photographs and the spirit of discovery that marked the era of western exploration are of special importance for Mark Klett.

Beginning in 1976, Klett spent three years replicating the pioneering work of the early expeditionary photographers.[1] The exhaustive study of those photographs, search for original sites and camera positions, and careful duplication of views gained for Klett a sense of how the western landscape had first been surveyed and prompted him to develop new records of his own. Unquestionably, Klett's work bears the formal and philosophical mark of the early photographs of Timothy O'Sullivan as well as references to William Henry Jackson and A. J. Russell.

In his quiet black-and-white photographs of the Southwest, Mark Klett reveals his interest in space, time, and the changing western landscape. He juxtaposes the small, personal scale of human existence against the spacious terrain, often humorously cast. In his search for artifacts, Klett examines remnants of the past as well as the interstices of his own daily activities.

Klett's training as a geologist equipped him with a scientific methodology and knowledge of the land that complemented his training as a photographer. His examination of the American landscape thus unfolds as an extremely logical combination of two divergent disciplines.

As William Jenkins has noted,[2] Klett has been influenced by the writings of J. B. Jackson, whose collected essays articulated a theoretical foundation concerning the nature of the landscape and its evolution, from the past that can never be recaptured toward the future.[3] Klett's approach and objectivity toward change in the West comes directly from Jackson.

Klett has worked chiefly in black and white, although since 1981 he has also produced dye-transfer prints. Virtually all his images are of the open lands of the western Rocky Mountains from Idaho to Arizona. Elucidating the prosaic rather than the dramatic, Klett assumes in his images an intentionally neutral stance. Accordingly, his prints have a soft, even, slightly dull finish that is wholly attuned to the solemn quietude of the subject. Klett takes the image right to the edge of the sixteen-by-twenty-inch sheet, allowing no border. His use of Polaroid Type 55 P/N film is apparent by the irregular markings along the print edges. Utilizing the entire four-by-five negative, he includes the uneven striations and patterns that frame the image, thus giving each a discrete, manipulative earmarking. The eroded edges, moreover, directly correlate with O'Sullivan's seminal negatives.[4] Also characterizing his work is the use of the wide-angle lens and distinctive entitling of the print along the lower edge.

The handwritten captions are integral to each print and demonstrate in the precise choice of details Klett's very considered method of working. Written in silvery ink and generally legible, the title contributes a greater depth to the work. Events or subjects are inscribed on the left with the location and date on the right. Although they are chosen with extreme care, many of Klett's titles, such as *Checking the road map: Crossing into Arizona, Monument Valley 6/22/82*, 1982, have the same informality and curious selection of insignificant events that readily recall the casual snapshot in a family photo album. Through the titles, the images become tremendously personalized, yet also reflect unacknowledged common experiences.

Fig. 1.   *Pausing to drink, Peralta Creek trail, Superstition Mtns, Az 1/8/83*, 1983.

Fig. 2.   *Returning to Phoenix: Start of the rainy season, near Payson, Az 7/10/83,* 1983.

Fig. 3.   *Motorcycles speeding past, dirt road near Apache Jct., Az 10/10/82,* 1982.

More significant is Klett's use of the title to chronicle the quotidian gesture, memorializing obscure, insignificant events: pausing to drink (fig. 1), checking the map, picnicking, waiting. By identifying a definite and precise event in time, the specificity of the image mitigates the timelessness of the landscape view. The importance of this particularity for Klett is substantiated by the thorough dating, including the day, month, and year, on each print. Furthermore, such complete recording confers a certain documentary quality to the photograph.

Some of Klett's titles locate the activities in sidereal, or seasonal, time. This scientific notation suggests a larger period, an awareness of the seasons and changes occasioned by them. The summer solstice served as a fitting time for a photograph as did the beginning of the rainy season. *Returning to Phoenix: Start of the rainy season, near Payson, Az 7/10/83,* 1983 (fig. 2), is a simple, panoramic view transformed into a marker identifying the site, time, and climactic cycle.[5]

Klett's titles express the episodic nature of the single image. Collectively they become a narrative or travel diary commemorating the anecdotal episodes and caesuras of daily movement. The handwritten notations are in concert with the informality of the image, further reinforcing the diaristic qual-

ity. The shift of the image into that mode, and as a group there is a strong diaristic account, results directly from the precise titles.[6] No longer timeless, the scene becomes particularized by the caption, which pointedly refers to Klett's interludes and rambles.

Another certain source for Klett's titles, allied to his work methods, is the nineteenth-century practice of identifying the location of the scene at the bottom of the print. Additionally, by capturing those fleeting moments occurring before and after the recording of the panoramic view, Klett refers to the mundane moments during the first surveys, as in, for example, O'Sullivan's *Snug Harbor, Black Canon. Halt for the Night. No. 5,* 1871.

The titles suggest a direction for the viewer, either amplifying the subject or, at times, contradicting the visual information of the photograph. Figure 3 offers a view of a dusty, vacant, desert road, where the wind has caught the dirt, blowing it into the empty air. The unobtrusive script belies the apparent, for the image is entitled *Motorcycles speeding past, dirt road near Apache Jct., Az 10/10/82.* Not simply photographic trompe l'oeil, the image is a clear articulation of Klett's interest in time and the ephemeral moment. Again he poses a juxtaposition between the vast timelessness and scale of the

land and the transitory, mundane incident. Furthermore, the titles emphasize the concept of the artifact. Laden with information about specific places and times, the prints become artifacts of our own time.

With his multilayered titles Klett decisively delimits and expands the context for his landscapes. The title implies a purposeful scrutiny and examination, not only looking back in history but also observing present-day culture. By his titles he makes plain his interest in capturing more than a simple, panoramic view. The Indian petroglyphs seen in several images are the most obvious and literal of the artifacts to which Klett alludes. His titles refer also to the role of the photographs themselves as the truthful witness, as artifacts of the artifacts. The content of various views–encroaching subdivisions, vandalized wall of an undeveloped housing project, bullet-riddled cactus–reveals Klett's awareness of the nature of some of the modern artifacts left in the West. Like the petroglyphs, the wall of the abandoned housing project stands as a cultural remnant and makes poignant reference to *Inscription Rock*, O'Sullivan's study of an early artifact.

Were it not for the items in the foreground, a somewhat dry, thoroughly classic vista of the Grand Canyon would be offered in *Picnic on the edge of the rim, Grand Canyon, Az 2/21/83*, 1983 (pl. 20). With a quiet insouciance, Klett has introduced into the frame a bold visual element. He approximates Alvin Langdon Coburn's photograph of the Grand Canyon in an unusual, updated manner. Contrasting elements, so characteristic of this body of work, are once again evident. The prominent placement of legs and luncheon provisions is distinctly at odds with the otherwise revered view of the canyon. These items establish an abrupt disjunction between the distance and the foreground and remove any sense of timelessness about the scene because it has now become particularized.

The scale measures included in this work are an inverted reference to those majestic nineteenth-century panoramas in which were incorporated minute human figures to heighten the drama and vastness of the new territories depicted. Klett's device is simply more informal, wryly exploiting the paradoxical visual discrepancies of photographic vision.

The legs thrust into the frame from the lower left literally inject man into nature, calling attention to his continuing en-

croachment into the western wilderness. More importantly, Klett demonstrates the contrast of time between the transitory picnic, known only through the photograph, and the epochal, geologic age of the canyon. Klett illustrates here, and throughout the group, the ephemeral poised against a millennial landscape.

Unlike the more spacious views typifying Klett's photographs is *Petroglyphs in the Cave of life, Petrified Forest, Arizona 5/31/82*, 1982 (pl. 26). Radiant sunlight pours through the confined interior of a cave to illuminate Indian carvings and confer on them a spiritual aura. Pressing down overhead, the rock formation contrasts with the bright, blinding light. Together they establish the strong diagonal that sets the physical context for the drawings. Klett utilizes the tight space and brilliant beam of light to suggest the magical quality of the location. The caption confirms the importance of the site: it is the cave of life. The simple, descriptive title invests the scene with a sense of divinity. The shifting ray of light contrasts with the enduring presence of the drawings, articulating Klett's concern with time and scale on many levels. *Cave of Life* is rather different from others in the petroglyph group, such as *Spiral carving facing east, Signal Hill, 5/7/83*, 1983 (pl. 28), which are more open, direct, and less mysterious. In these records of their artifacts, Klett pays homage to bygone Indian cultures.

Those inscriptions form a counterpoint to the graffiti of *Vandalized wall, undeveloped subdivision, Carefree, Arizona 2/27/82*, 1982. Klett does not use his photographs to espouse any fervent environmental polemic but rather records objects and scenes with equanimity. Some contemporary artifacts readily suggest themselves as appropriate and ironic memorials to our culture.[7] The Carefree site and *Sedona vista, subdivison, from Chapel of the Holy Cross, Sedona, Az 4/17/82*, 1982 (pl. 27), are evidence of current land use in the Southwest with its proliferation of housing tracts encroaching upon extraordinary locations.

Many of Klett's photographs look out toward the horizon across an open plain, only rarely invoking the full dramatic majesty of the land. A perceptible stillness, so characteristic of his photographs, is especially evident in the painfully simple composition, *Plywood Tee-Pees, Meteor Crater, Az 5/30/82*, 1982 (pl. 22). A blank, light sky dominates a band of darkness,

punctuated along the horizon by five small triangular shapes. The foreground–a sea of dark, textured flora–contrasts sharply with the smooth sky. With its massive, horizontal, tonal registers and profound absence of detail, this minimal array is endowed with a powerful presence.

Klett points to the disparity between the efforts of man and the monumental scale of nature. The telephone poles in the distance appear as mere scratches on the print, confirming the vastness of the open terrain. Klett has made the tepees the smaller component, barely jutting into the sky, even though they are the ostensible subject of the photograph. Once again the visual enigma of the image is clarified by the title. The curious Indian encampment is disclosed to be but a latter-day fabrication, an ersatz corruption. This parodic reference of the American Indian additionally alludes to the genre of tawdry, vernacular architecture formerly dotting old highway routes, now artifacts themselves. And so, Klett presents another of the various artifacts uncovered in his search.

Klett depicts here a barren landscape virtually unchanged for millions of years, and with this image he adroitly poses the disparity between geologic time and human existence. The plywood structures will not withstand the forces of nature and are as ephemeral as the other moments captured by Klett. This concern with the passage of time again points to the influence of O'Sullivan, for whom it was also a recurrent theme. *Plywood Tee-Pees* testifies to the century-old views by Jackson and O'Sullivan, respectively, *View on the Sweetwater,* 1870, and *Alkaline Lake, Carson Desert,* 1868. An elegiac mood is struck in the emptiness and stillness of the wilderness, recalling the bygone era, the closing of the frontier, and the intervening time since the surveys.

Equally simple in compositional detail is *Car passing snake, eastern Mojave Desert 5/29/83,* 1983 (pl. 24). Here Klett patiently uses the photographic method to manifest his examination of the passage of time, reducing a moving object to a blur. Again the title supplies the necessary clue needed to make sense of the image. The car, nonexistent save for Klett's legend, speeds past the coiled snake, laconically alluding to the antithetical presence and velocity of the two. Curiously, the car is partially depicted by a striped band not unlike snakeskin. Wholly at risk on the highway that slices through the desert, the snake is emblematic of the fragility of the desert intersecting with advancing civilization.

Further evidence of the Southwest's fragile ecosystem is found in *Bullet riddled saguaro, near Fountain Hills, Az 5/21/82,* 1982 (pl. 21), an empty, haunting landscape, perhaps the most poignant of Klett's hushed images. The cruciform shape of the cactus just off-center is the primary focus. Vertically bisecting and linking earth and sky, the cactus is solitary in its totemic prominence. The plant has been ravaged not by the vicissitudes of nature but by man, who has found its form perversely satisfying as a target. The cactus, looming in the foreground, focuses our attention on the disparate scale of the distant expanse. Characteristically, Klett has used a narrow tonal range, eschewing the dramatic in favor of the subtle. The form of the saguaro is echoed diminutively back into the far reaches by the scores of other cacti hidden in the textural pattern of the rolling hills.

In *Beneath the Great Arch, near Monticello, Utah 6/21/82,* 1982 (pl. 29), Klett once more exploits the lenticular transformation of the wide-angle lens to accentuate a stupendous difference in scale. The massive curve of the arch sweeps overhead, taking root in the center of the frame. Set against the base of this gargantuan geologic form, the human figure is miniscule. The portrayal recalls conventions employed by O'Sullivan and others to demonstrate the enormous power and immensity of nature, such as Russell's *Skull Rock, Dale Creek Canon,* 1867–68, an early model for the compositional placement of a tiny figure overwhelmed by massive land formations. Along with the scale in Klett's view is the representation, personified by the figure, of time in human terms rather than defined by geology. In the vast emptiness, the human figure is isolated and vulnerable, much as O'Sullivan saw him. Although seemingly akin to the snapshot in format, the ambiguous rendition of the figure clearly indicates that Klett used the individual for illustrative purposes and not as the primary subject.

In *Campsite reached by boat through watery canyons, Lake Powell 8/20/83,* 1983 (pl. 25), human scale, represented by sleeping bags and piles of equipment, is again thoroughly overwhelmed by the immensity of the barren land. Moreover, the inescapable remoteness of the location and eerie, almost lunar terrain emphasize the profound isolation and vulnerability of man in the wilderness.

Fingers of stone reach into the glassy plane of the placid lake. The atmosphere is one of utter, sublime silence. Here Klett does not overemphasize nature's monumental scale but rather uses the harshness of the forbidding terrain to establish its dominance.

Those seemingly unimportant interstices between events, those unrecorded stopping points, are honored in *Checking the road map: Crossing into Arizona, Monument Valley 6/22/82,* 1982 (pl. 23). Pulling off the road where tourists routinely take their memorial photographs of Monument Valley, Klett records the view not in front of his truck but inexplicably from the rear, giving a peculiar, unexpected prominence to the U-Haul. The caption thoroughly clarifies his diaristic intent: it is the rest stop to reconnoiter that he seeks to record and not the anticipated scenic view.

He has somewhat baldly used the truck as a device, like the lunch in *Picnic on the edge of the rim,* to emphasize the striking disparity among various elements. And as in that image, Klett manipulates the scale, reversing his more customary illustration of the relationship between man and nature. Klett offers his rented truck as a modern artifact for future scrutiny. At the same time he is also alluding to the wagons, barges, and mules that carried the topographic photographers into the wilderness a century ago.

It is the land that dominates Klett's images even when it is serving as a backdrop for activity. The long, deep view, delicate range of grays, and open sky all express a sober respect for the western terrain. *View of the Superstition Mtns from the Salt River October 31, 1982,* 1982 (fig. 4), like so many others, openly acknowledges a debt to the survey work of nineteenth-century photographers and the American landscape tradition.

Throughout his works, Klett reveals himself to be precise and thoughtful. With his capacity for recording the incidental as well as the epochal, Klett parries the trivial with the timeless. Presenting a collection of episodes experienced over the course of several years, *Searching for Artifacts* chronicles the artist's peripatetic examination of the Southwest, the relationship of man to nature, and the cultural remnants left on the ever-changing landscape.

Fig. 4.　*View of the Superstition Mtns from the Salt River October 31, 1982,* 1982.

NOTES

1.　The results of this exhaustive research and work rephotographing the original views of Jackson, O'Sullivan, Russell, and others can best be examined in the comprehensive comparative volume *Second Views: The Rephotographic Survey Project* (Albuquerque: University of New Mexico Press, 1984).

2.　William Jenkins, "Mark Klett Touring Arizona," *Artspace* 8, no. 2 (Spring 1984): 12–15.

3.　J. B. Jackson's texts include *Discovering the Vernacular Landscape* (New Haven, Conn.: Yale University Press, 1984); *Landscapes: Selected Writings of J. B. Jackson* (Amherst: University of Massachusetts Press, 1970).

4.　See Rick Dingus, *The Photographic Artifacts of Timothy O'Sullivan* (Albuquerque: University of New Mexico Press, 1982), pp. 105–36.

5.　The sidereal has intermittently appeared in Klett's titles, among them: *Last day of Summer, evening of the Fall equinox, 9/21/80; First day of Summer, evening of the solstice, Phoenix 6/21/83; First day of Spring north of Winnemucca, Nv.*

6.　Dana Asbury, "Inventing a Self: Autobiography and Contemporary Photographers," in *Self as Subject: Visual Diaries by Fourteen Photographers* (Albuquerque: University Art Museum, University of New Mexico, 1983), p. 10.

7.　The isolated wall to the undeveloped subdivision bears two disparate slogans: "SAVE OUR DESERT" and "KILL ECOLOGY FREAKS."

PLATE 20

Mark Klett, *Picnic on the edge of the rim,*
*Grand Canyon, Az 2/21/83,* 1983

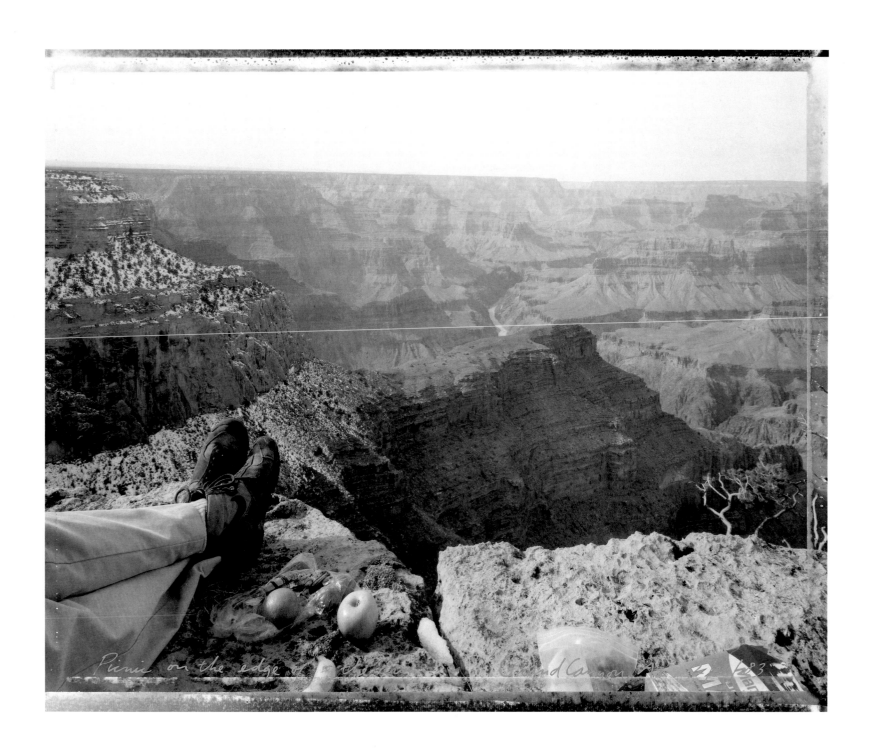

PLATE 21

Mark Klett, *Bullet riddled saguaro, near*
*Fountain Hills, Az 5/21/82,* 1982

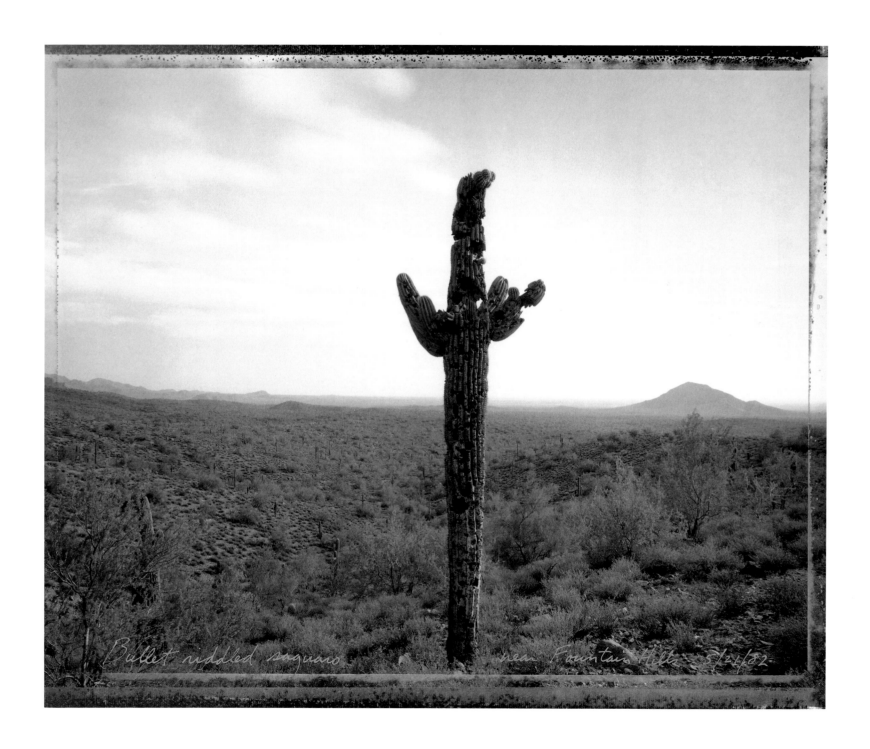

PLATE 22

Mark Klett, *Plywood Tee-Pees, Meteor Crater,*
*Az 5/30/82,* 1982

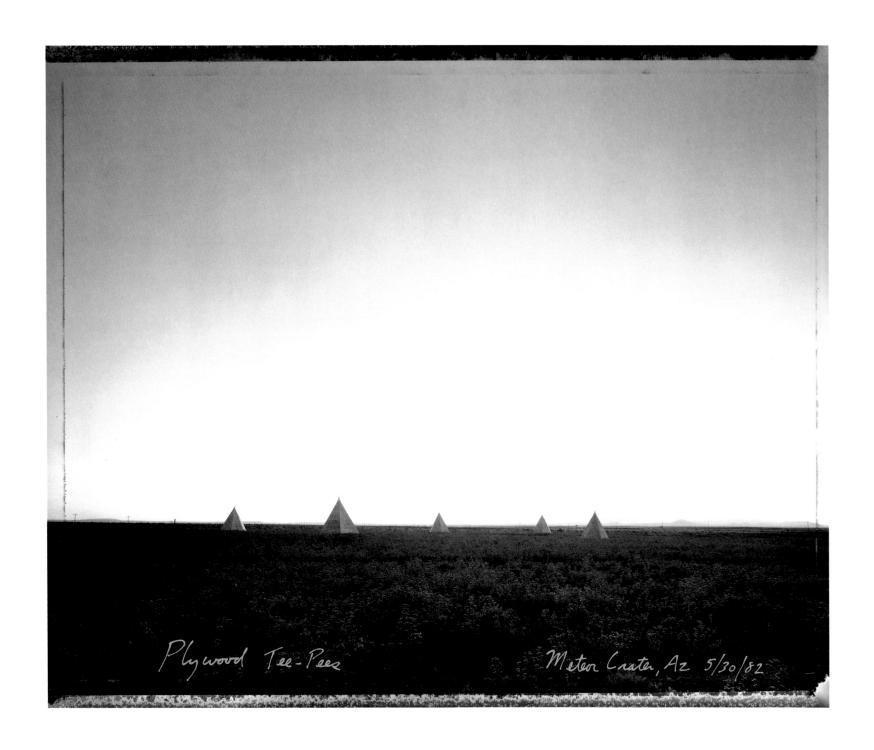

PLATE 23

Mark Klett, *Checking the road map: Crossing
into Arizona, Monument Valley 6/22/82*, 1982

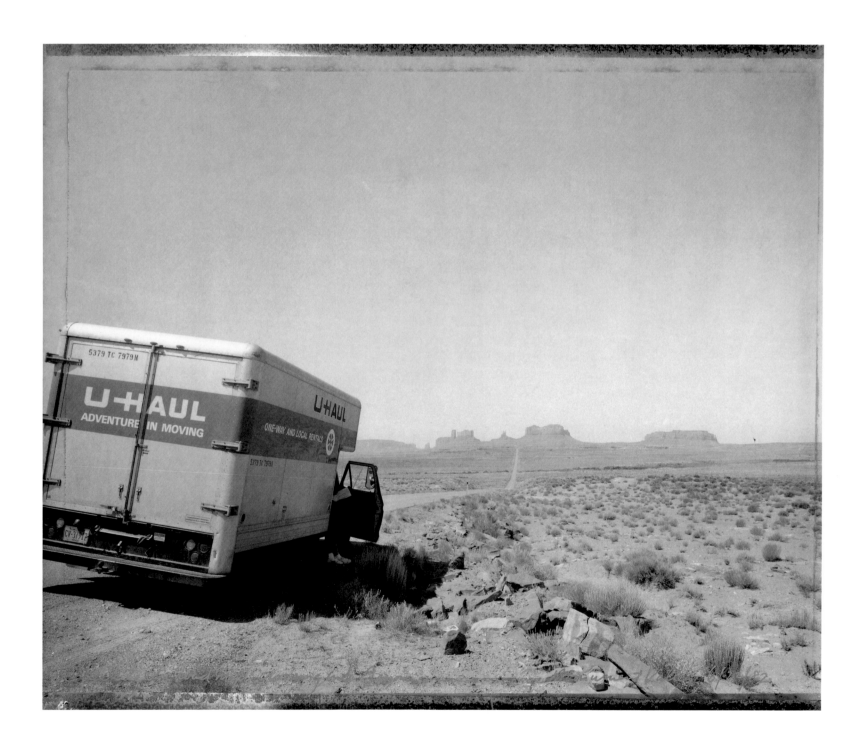

PLATE 24

Mark Klett, *Car passing snake, eastern Mojave
Desert 5/29/83*, 1983

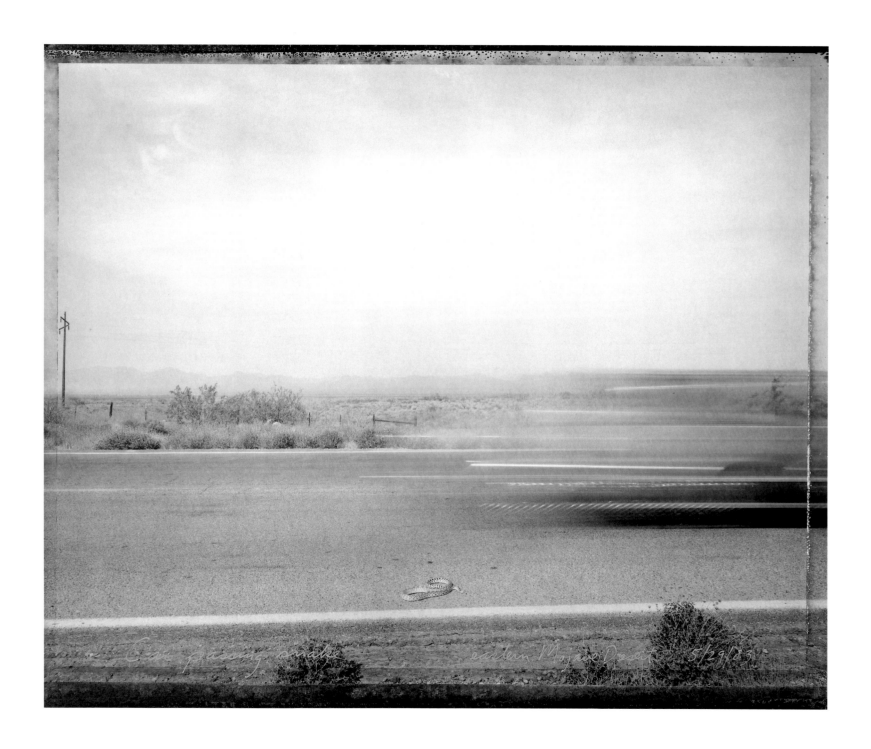

PLATE 25

Mark Klett, *Campsite reached by boat through watery canyons, Lake Powell 8/20/83*, 1983

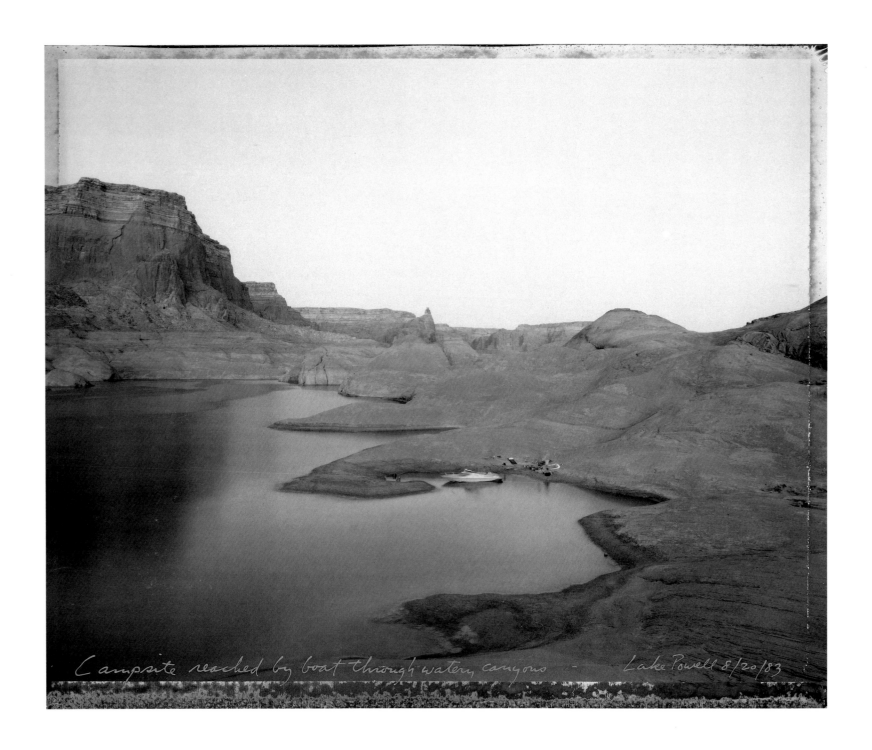

PLATE 26

Mark Klett, *Petroglyphs in the Cave of Life,*
*Petrified Forest, Arizona 5/31/82,* 1982

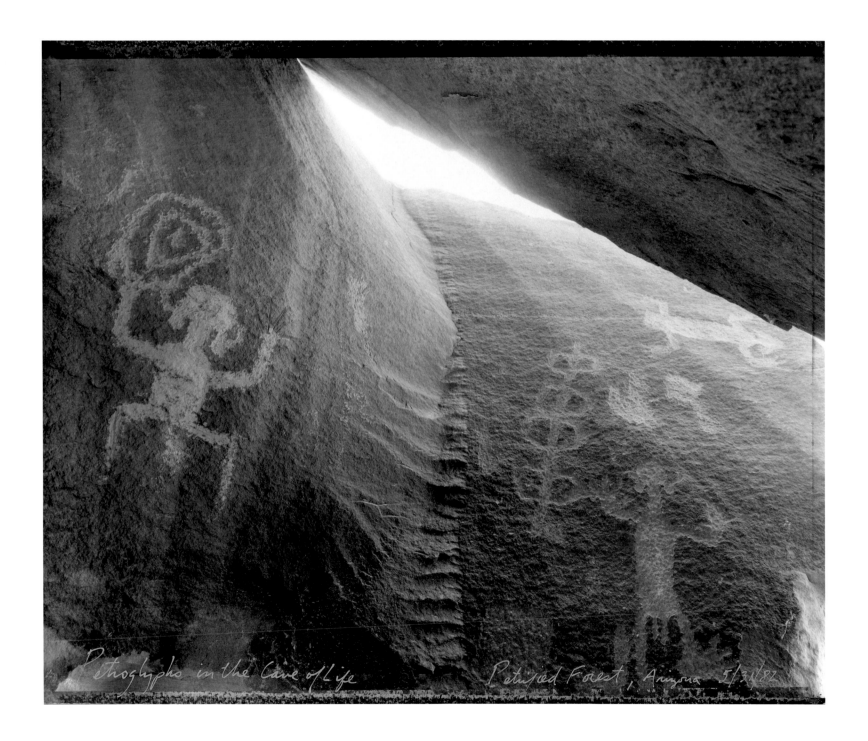

PLATE 27

Mark Klett, *Sedona vista, subdivision, from Chapel of the
Holy Cross, Sedona, Az 4/17/82*, 1982

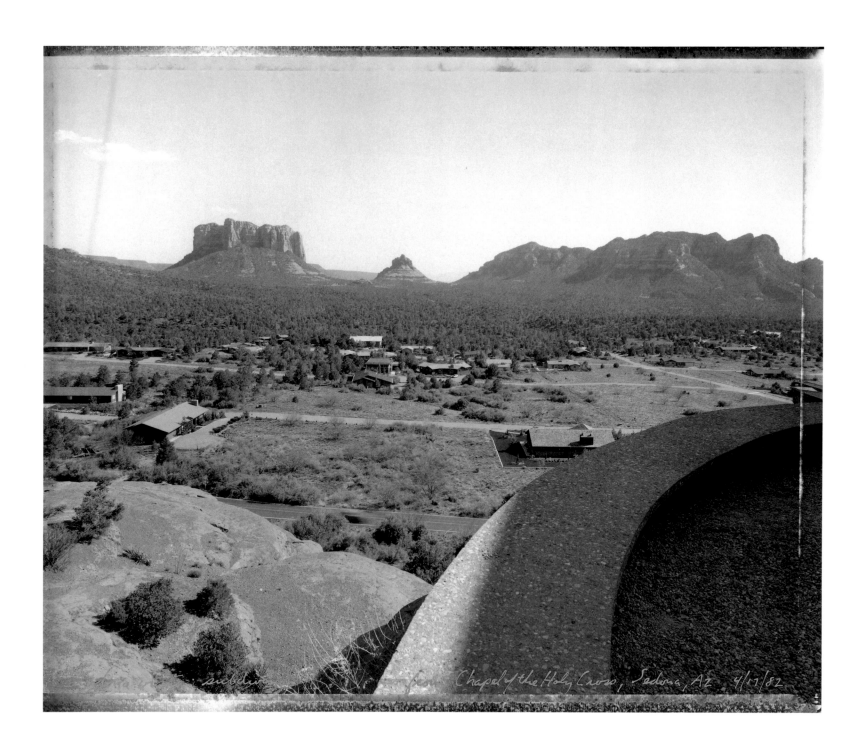

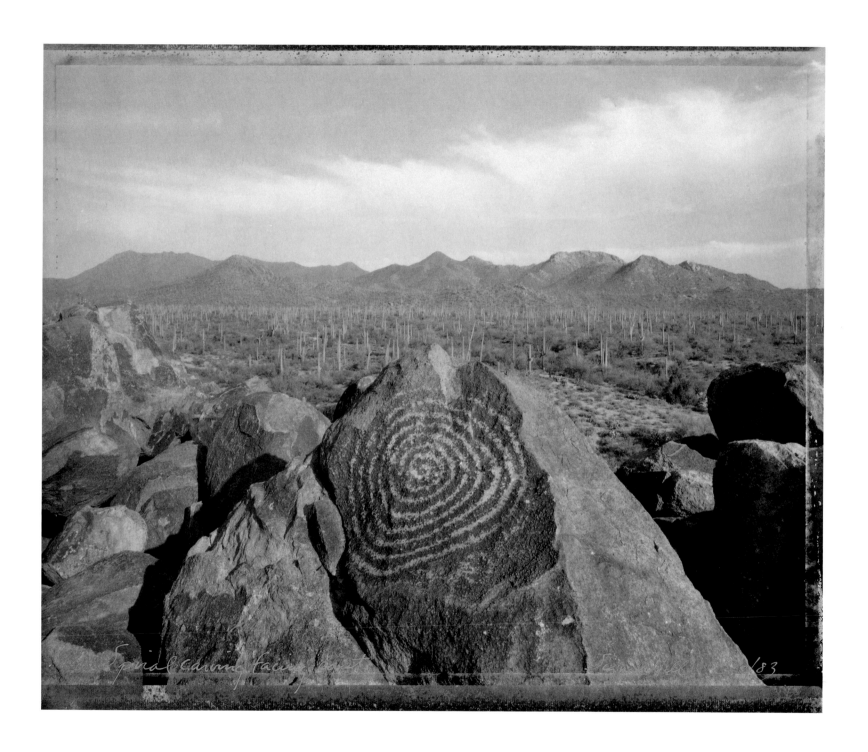

PLATE 29

Mark Klett, *Beneath the Great Arch, near Monticello, Utah 6/21/82*, 1982

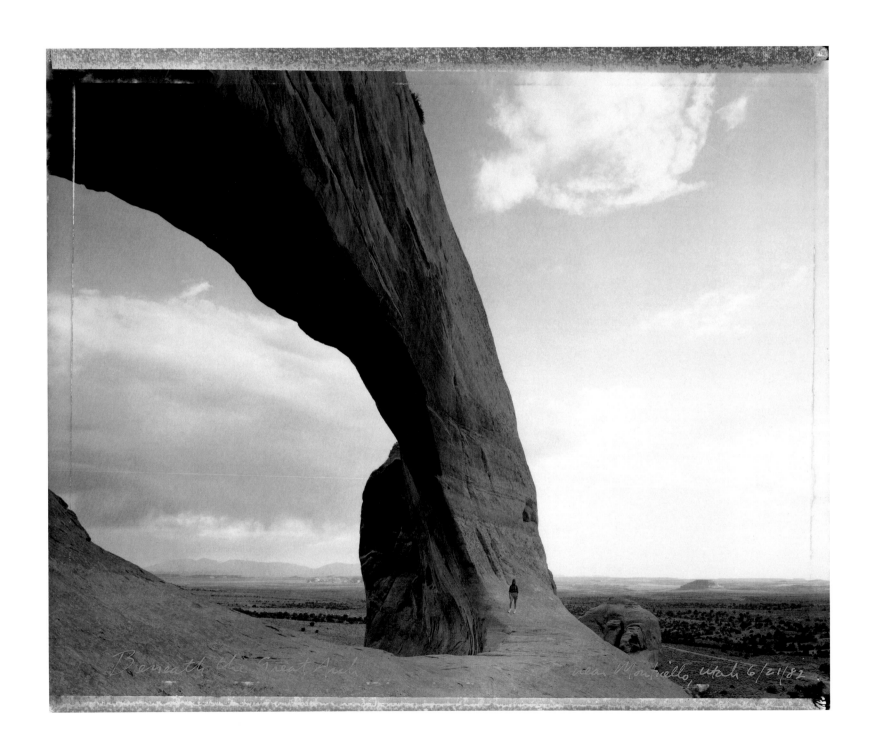

# Wendy MacNeil

For more than twenty years Wendy MacNeil has been occupied with a single subject: portraiture. Moving steadily toward simpler iconic presentations, she has photographed her family, friends, students, and colleagues in her exploration of portraiture. The title *Family Portraits* refers not only to her immediate family but also to groups that for MacNeil function in ways not unlike families. It is the group as a whole rather than the isolated individual that is of interest to her.

In 1966 MacNeil first undertook a project to photograph people in the Haymarket area of Boston. Following this experience, she eschewed the more public, social documentary approach in favor of the personal as she sought different means to obtain a portrait and focused on subjects closer to herself.

Much of the success of the portraits is owed to her exquisite materials. Indeed, the ineffable aura and spirit of the images could not be achieved with the more prosaic silver prints. During the mid-1970s, MacNeil rejected traditional photographic materials, finding them too exacting, too conventional, and their rendition of the subject far too literal. Seeking to move beyond verisimilitude and the specificity of time, MacNeil experimented with various processes and papers, searching not for some alternative medium but rather for a truly appropriate vehicle expressive of the qualities she wanted to capture in portraiture. Rives paper, for instance, failed to work, and processes, such as vandyke, did not provide the required depth, brilliance, or "life." Eventually she found the antique platinum and palladium processes to yield ethereal nonphotographic qualities that she desired and also possess an ideal delicacy, strength, and sensitivity. Additionally, when the emulsion was combined with translucent vellum tracing paper, the image assumed a remarkable luminosity while projecting a fragile, rare quality. Isolated from a context and located in the very center of the sheet, the portrait floats on the paper, contributing to the timelessness of the image. At once intimate and objective, the portrait directs attention to the simple, often overlooked details of a subject. Oddly though, it is the unusual media that emphasize the content over the material. It was important to MacNeil that the materials not eclipse the subjects but rather add to their presence. Although exceedingly sensitive portrayals, the prints

have neither a preciosity nor any of the antique qualities usually associated with contemporary platinum prints.

Throughout the 1970s MacNeil utilized old portraits, commingling casual family snapshots and formal studio portraits. Often taken at watershed occasions in the subject's life, the photographs were arranged in a montage revealing and connecting the person's past, family relationships, and physiognomic heritage. MacNeil was engaged in a narrative, longitudinal study of the subject, establishing a historical context for the contemporary portrait to disclose startling similarities as well as inexorable change.

Writing about her portraits, MacNeil stated: "For the past few years I have collected snapshots from family and friends and put them with my portraits. Another album—a series of biographies—has begun to form. Despite many changes of time and style, the essential expressions of a person's life are always there to be seen. Resemblance to other family members and to ancestors often emerge."[1]

Beginning with the group informally referred to as Album Pages, the change in materials contributed substantially to the aura of the new works, mitigating the reportorial, thus effecting a major shift from the earlier portraits. The result is a biographical whole of interrelated elements transcending the ordinary assemblage of discrete personal artifacts, melding them into a synergetic portrait. A complex, often contrapuntal vision of the subject is produced. MacNeil makes very few prints of an image. She frequently reworked the composition of these Album Page portraits, considering each revision somewhat like a different state of the portrait. Consequently, a particular version may not be printed for years following the making of the original negatives.

Certainly the use of snapshots in photography has had a long history. In *Ronald MacNeil*, 1977; printed 1980 (pl. 39), MacNeil displays an insightful selection of disparate material, which she incorporates effectively to achieve something beyond physical or psychological presentation. As with all the portraits in this group, old photographs providing clues and facts about the subject's past are arranged on the sheet. Below the central triptych formed of expired identification cards spanning approximately twenty years, roughly from the late 1950s to the 1970s, is a predella of smaller, casual portraits. The earliest identification card, issued by the Atomic Energy

Commission, presents a child's face gridded off by lines and bars, a portrait type reminiscent of those formerly found in post offices. An array of miscellaneous details regarding the subject's background and family are composed as a narrative biography. The portraits arranged across the bottom edge keep pace with the evolution in the top register. Somewhat aptly, the center image is blurred, stressing the decided differences among the four portraits on either side of it. The nonchalant pose and long hair of the subject of the identification card from the Rhode Island School of Design mark the biographical changes since the earlier, straightlaced government photos.

The portraits of hands commenced in 1977, when MacNeil made the first photographs of Adrian and Ezra Sesto. By 1980 the series was in full progress, and a loose group of portraits emerged, all employing the hands of people close to MacNeil, her family and friends. The most enigmatic group, the hands proffer less of the typical visual information expected from portraits and at first seem more generalized. They are, however, entirely consistent with MacNeil's other groups and illustrate her continuing expansion of the limits of portraiture and investigation of alternative representations of a subject.

MacNeil was intrigued by the possibility of basing a meaningful portrait on physical elements other than the face. Because of their generalized appearances, these works transcend the specificity of a particular place and time, an unusual characteristic for a portrait. The simple iconic format underscores the timelessness. Indeed, these images of human hands are at once particular and universal, and their strength lies precisely in that conjunction. The hands possess a haunting, ethereal quality. By their placement in an empty field and neutral, straightforward presentation, the hands are wholly unromanticized. These images describe the familial relationships and connections of the Album Pages, although in a more symbolic and abstract way. Presented singly, not as a pair, the images are devoid of the usual emotion, personalizing, or idolizing seen in other representations of hands.[2]

The manner of presenting the upraised hand, open with the palm forward, renders it in such as unadorned documentary fashion that this format might serve equally well for anthropological studies, so totally neutral is its appearance. Moreover, the raised hand is an enduring and transcendent sign, unaffected by millennia or culture. The hands have a certain generic truth about them. But while the hands are sufficiently universal to serve as portraits of everyman, there is no doubt that they are representations of individual persons. Perhaps it is this duality that makes them so insistently comparative.

*Andrew Ruvido and Robyn Wessner*, 1981; printed 1982 (pl. 31), is a special portrait, one of the few pairs photographed by MacNeil. Placed side by side, the two hands provide a pattern of dark, rich blacks, grays, and whites, with an extreme contrast between the dark palm and pale sensitive skin of the

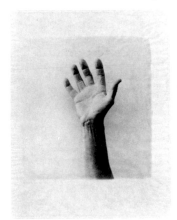 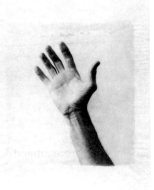 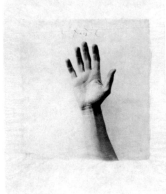 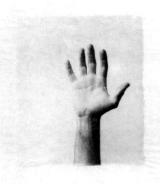 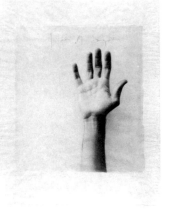

Figs. 1–5. *Snyder Family Portrait*, 1980; printed 1984.

forearm. MacNeil purposely leaves much to interpretation, guiding us only slightly with the title. Nonetheless, the subjects share an implicit bond of companionship. Both palms are covered with dark earth, most apparent on the encrusted palm of Robyn on the right.

*Snyder Family Portrait*, 1980; printed 1984 (figs. 1–5), comprises five sheets. Unlike the family portrait made to commemorate a very specific event or time, these images are not bound by such particularity. By virtue of the whole, that is the entire family portrayed together, the specific ritual or portrait making on the occasion of a family gathering is implied. It is essential to view the prints at one time, comparatively, for each hand is a fragment of the complete group portrait. Again, as with certain Album Pages, a dominant physiognomic characteristic manifests itself. Here, the lean and angular palm and thumb testify to the familial bond among the subjects. MacNeil has purposefully used signatures above each hand to identify the individual. Furthermore, the script also brings to mind the identifying names and notes found on the back of snapshots. The group has an etheral presentation owing to the linear, attenuated hieratic form, lightness of tonality, and delicacy.

In contrast, *My Grandmother's Hand*, 1983; printed 1984 (pl. 32), presents a clear, unemotional testament to the enduring strength of an elderly woman. This image graphically speaks of a life of experience and is not in the least cloying or sentimental. The gnarled hands and broadened digits afflicted by arthritis depict the physical effects of aging, suggesting that the hands, like the face, chronicle one's life.

After 1980 MacNeil abandoned the montage format of the earlier Album Pages and began concentrating on the faces of her subjects. Central to this realignment was the belief that the face was the reservoir of experience and carried with it the residue of individual history. These works are much more physically oriented and are less about pictorial composition and arrangement.[3] MacNeil sought a portrait that would capture the spirit, the persona, of her subject and has studied various historical sources from Egyptian portraits to the Romanesque sculptures of Gislebertus. With these works the face increases in scale to become the sole focal point. The solemn, direct gaze; formal pose; and blank background all recall the daguerrean approach. These characteristics

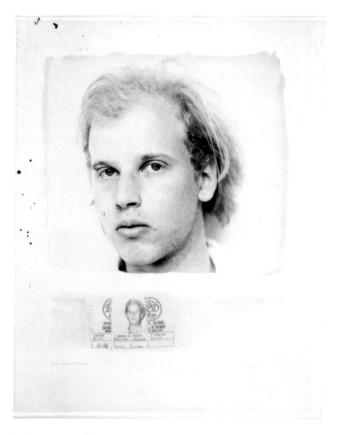

Fig. 6.   *Jamie Wolff*, 1979–80; printed 1982. From *The Class Portrait, First Year Graduate Students in Photography, Rhode Island School of Design.*

together with a shallow depth of field are evident in the reserved portrait of Eugenia Parry Janis (pl. 33) from *The Group Portrait of the Eight Tenured Members of the Art Department, Wellesley College (by rank)*, 1980; printed 1981. The unexpected vitality of the portraits in these groups is derived in part from their life-size proportion and simple presentation. Although somewhat abstracted in the black-and-white schema, the portraits possess extraordinary detail and rare delicacy that further strengthen their appearance. Any sense of stiffness is obviated by the soft translucence of the paper and gray nuance of the image. Thus the faces seem only quiet in their countenance not frozen. Because of her choice of materials, the portraits become more than mere

photographic reproductions. Detached from any physical context, personal or external, the portraits present a hieratic visage. MacNeil's portraits are quite different from those of many women photographers. She has not sought to locate her subjects in their milieu but rather has established a pattern of presentation that eliminates the vagaries of pose, lighting, ambience, and character. By eliminating all extraneous detail, MacNeil brings us, over and over, to the essence of the portraits: the face. These portraits must be compared to each other, both within a group and among the different groups.

MacNeil acknowledges the typological photographs of August Sander as an important influence for her group portraits. She does not, however, endeavor to address the encyclopedic range nor the broad social issues that were his concern.

*The Class Portrait, First Year Graduate Students in Photography, Rhode Island School of Design,* 1979–80; printed 1982 (fig. 6), was the first of three groups photographed by MacNeil. The neutral, simple presentation of subsequent portraits begins here. MacNeil confesses to finding elements of the heroic in her subjects. In the Rhode Island group portrait, the student identification cards are a holdover from the earlier Album Pages, in which a bit of the subject's past is brought along, providing an artifact to accompany the portrait.

The casual appearance of the graduate students contrasts with the professional, academic demeanor of MacNeil's second group portrait: *The Group Portrait of the Eight Tenured Members of the Art Department, Wellesley College (by rank),* 1980; printed 1981. In this portrait MacNeil sought to portray the core group of professors of the art department. Intense, scholarly art historians, all had been tenured within several years of each other. MacNeil had known the group since the early 1970s and long wished to record them as a unit. Many sittings were required, for the eight portraits did not come easily. The easy formality of the life-size faces most directly engage the viewer. The portrait of Lilian Armstrong (pl. 34), with her classic features and simple hairstyle, is highly suggestive of Italian quattrocento portraits. The elemetal, linear black-and-white composition achieves a remarkable affinity with the sitter's academic interest.

It is by comparison that the reserved characteristics of the Wellesley group are disclosed, especially in juxtaposition with MacNeil's most recent group portrait: *The Group Portrait of the 25 Fellows of the Center for Advanced Visual Studies, M.I.T.,* 1983–84; printed 1984. These portraits of experimental artists are slightly larger than the Rhode Island and Wellesley faces. The images are both intense and casual, elucidating far more individual character than in other portraits. The two Boston groups could not be more different. One is a relatively stable group, concerned with the factual study of the past, the other is fluid and changing, concerned with theoretical experimentation involving technology and art. Composed of working artists, the MIT group is highly eclectic. From Gyorgy Kepes, director emeritus, to the young video artists, the group shares a wide range of backgrounds, scientific interests, and art expertise.

The portrayal of Otto Piene and Rus Gant (pls. 35–36) typifies MacNeil's current approach. The closeness of the face brings details into high relief, increasing the intensity of the portrait. Not strictly frontal as with the Wellesley portraits or Ronald series, the MIT portraits are more aggressive, rendered with greater contrasts between darks and lights. Again, the shallow depth of field forces attention onto the facial features.

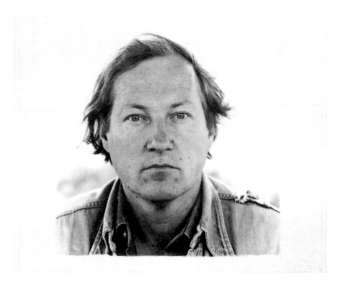

Fig. 7.   *Ronald,* 1981; printed 1982. From *Ronald,* an on-going portrait begun in 1980.

In late 1980 MacNeil initiated what has become after only a few years an extraordinary, extended portrait document on the artist Ronald MacNeil, her husband (fig. 7; pls. 37–38). As of early 1985 approximately two dozen excerpts of this on-going life project have been made. The emphasis entirely focuses on the face, with only minimal external intrusions. The style is neutral, reserved, and thoroughly uninflected, an approach that belies their relationship. Although the pose is unvarying, there is no slavish positioning of the subject. It is the constancy of the pose, with eyes gazing straightforwardly and the head at the same tilt and elevation, that affords such ready comparison between the parts of this longitudinal portrait.

As with the group portraits, the Ronald series attempts to define a whole comprising many parts. Again, each leaf is but a fragment, an excerpt from an open-ended serial project. A comparative reading is here absolutely essential since the true portrait cannot be restricted to any single image or narrow selection of images. Moreover, the protean portrait is constantly changing over time, becoming increasingly dense in each passing year, with the total appearance ever so slightly altering. The photographic truth of any one portrait is affected by the others, which are similar but disconcertingly different in subtle ways. MacNeil captures the slow mutability of the human visage. Ronald is more than her subject; he stands as an example to us of the vicissitudes of daily appearance. The Ronald series reveals the unspecific, rather imprecise variations in appearance that occur within only a few years.

As extended portraits, Alfred Stieglitz's photographs of Georgia O'Keeffe seem to be a relevant conceptual model, although his aims were distinctly different. MacNeil observed that it was the wives who were photographed by their husbands, and she is posing an alternative to the portraits of spouses by Harry Callahan, Stieglitz, and Emmet Gowin, which, by comparison, are decidedly more sexual and romantic. With MacNeil's portraits of Ronald a detached cerebral tact is employed.

In her portraits MacNeil has eschewed a psychological examination or character portrayal. Rather she has attempted to focus exclusively on the physical qualities of experience, especially as mirrored in her subjects' faces. For MacNeil the human visage is the reservoir of one's heritage and experience and is that which she has sought to present.

NOTES

1. Quoted from "The Snapshot," *Aperture* 19, no. 1 (1974): 68.

2. The occurence of hands in photographs has been seen repeatedly but, as in the work of Dorothea Lange, more often they are used as an expressive devise symbolizing power or emotion.

3. At this point MacNeil became aware that the compositional elements of the material were competing with the faces. As a result she eliminated all extraneous components, reverting to the single image.

PLATE 30

Wendy MacNeil, *Fred Stone and Father*, 1977;
printed 1980

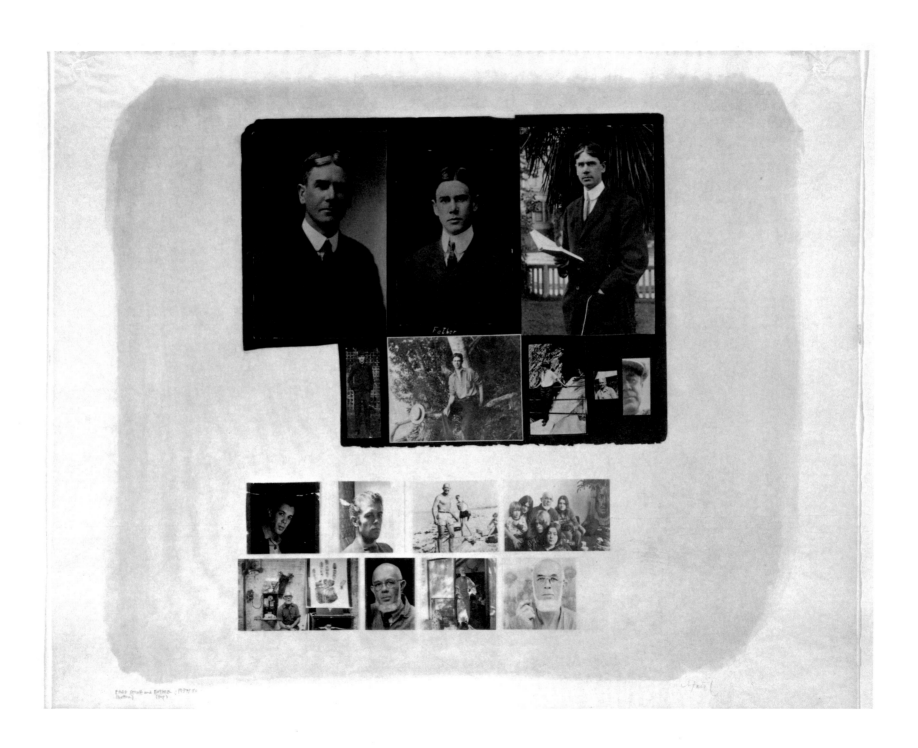

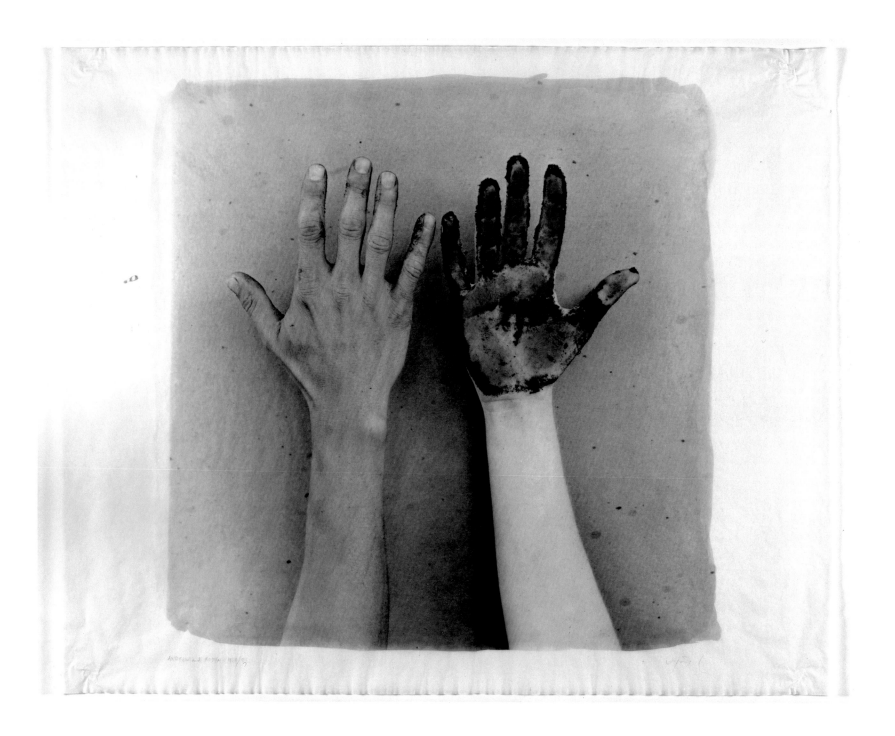

PLATE 32

Wendy MacNeil, *My Grandmother's Hand,*
1983; printed 1984

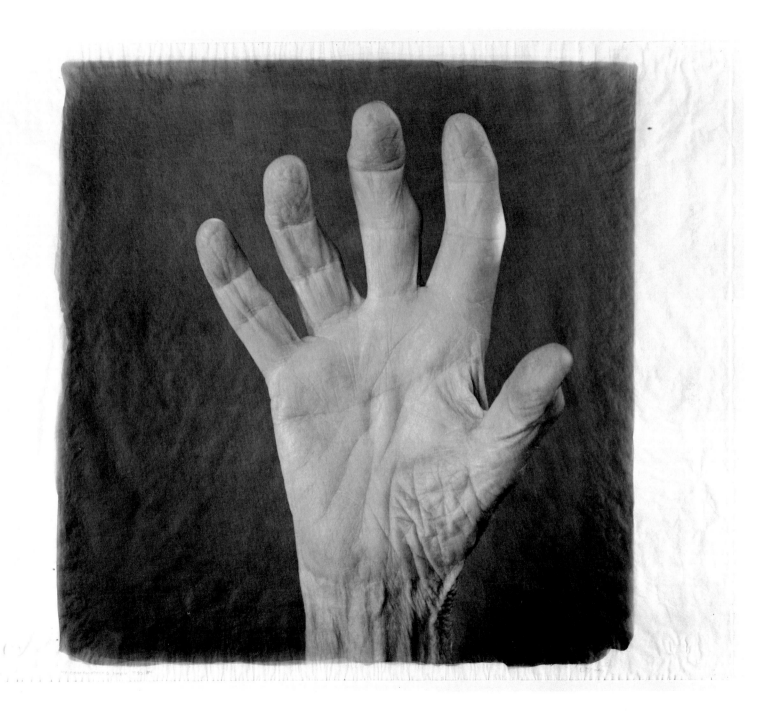

PLATE 33

Wendy MacNeil, *Eugenia Parry Janis*, 1980; printed 1981. From *The Group Portrait
of the Eight Tenured Members of the Art Department, Wellesley College (by rank)*.

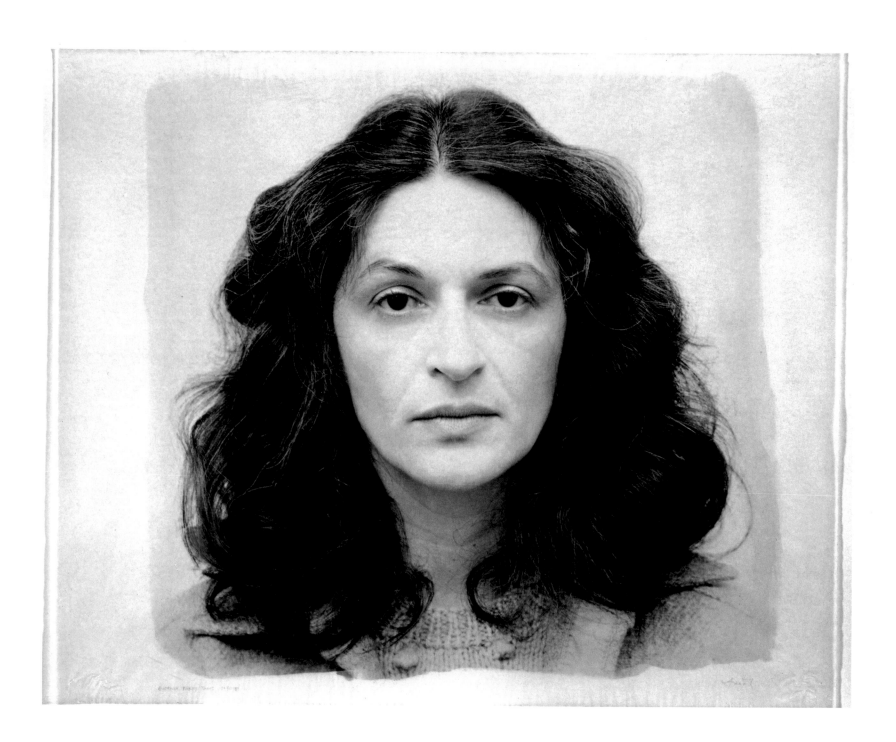

PLATE 34

Wendy MacNeil, *Lilian Armstrong*, 1980; printed 1981. From *The Group Portrait of the Eight Tenured Members of the Art Department, Wellesley College (by rank)*.

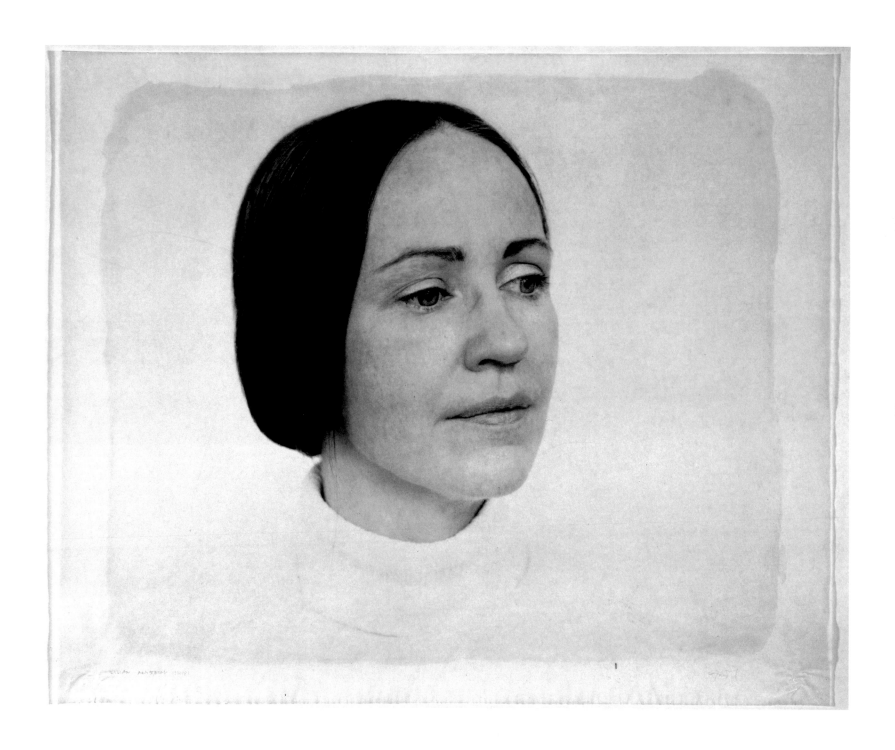

PLATE 35

Wendy MacNeil, *Otto Piene*, 1983–84; printed 1984. From *The Group Portrait of the 25 Fellows of the Center for Advanced Visual Studies, M.I.T.*

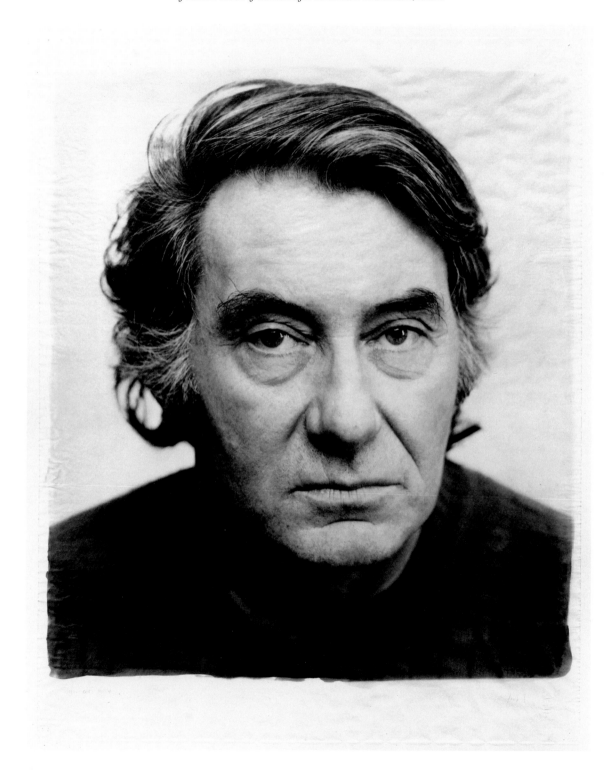

PLATE 36

Wendy MacNeil, *Rus Gant*, 1983–84; printed 1984. From *The Group Portrait of the 25 Fellows of the Center for Advanced Visual Studies, M.I.T.*

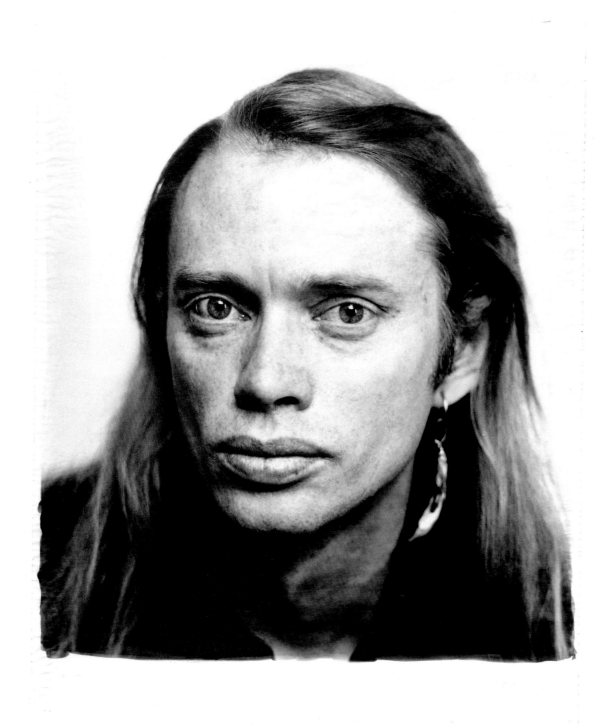

PLATE 37

Wendy MacNeil, *Ronald*, 1981; printed 1982.
From *Ronald*, an on-going portrait begun in 1980.

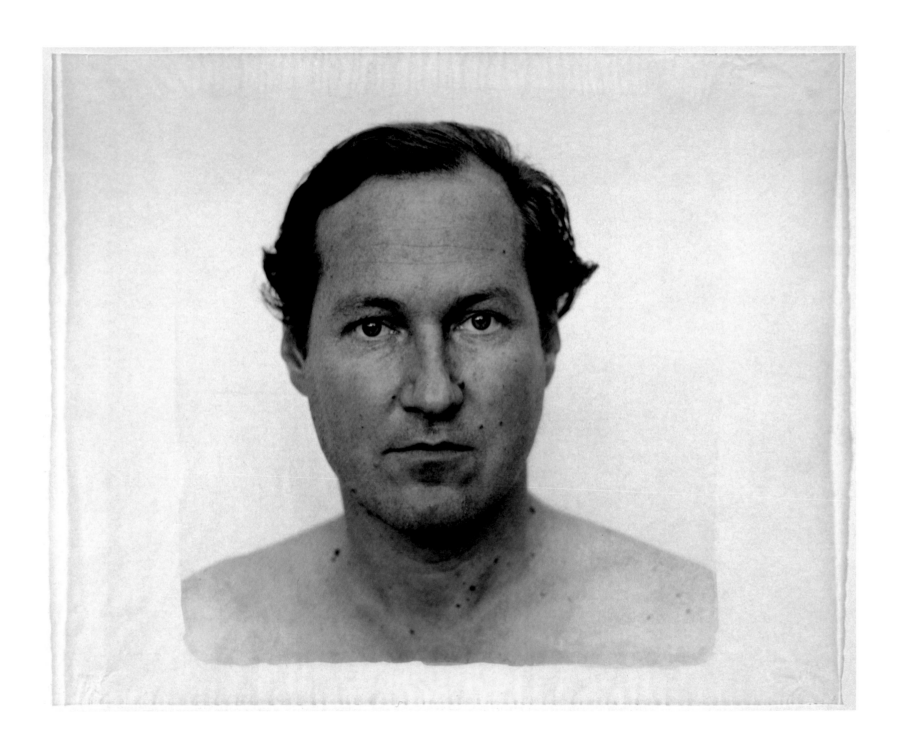

PLATE 38

Wendy MacNeil, *Ronald, 40th Birthday*, 1981, printed 1982.
From *Ronald*, an on-going portrait begun in 1980.

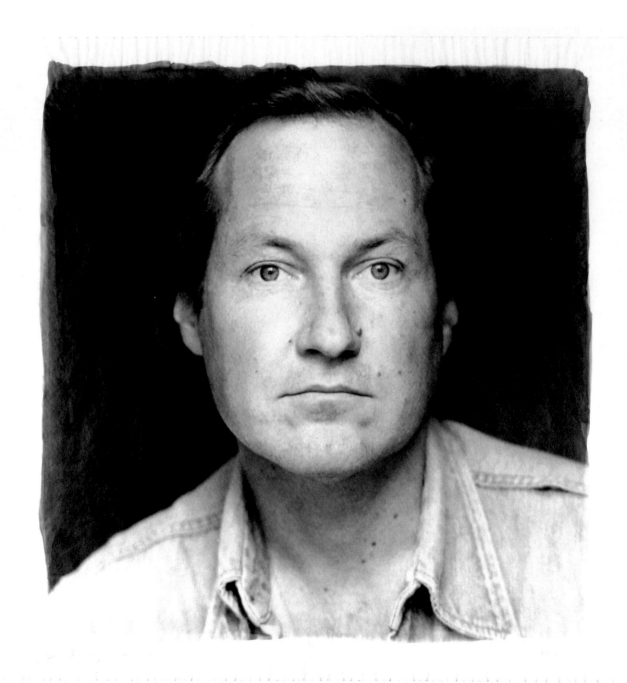

PLATE 39

Wendy MacNeil, *Ronald MacNeil*, 1977;
printed 1980

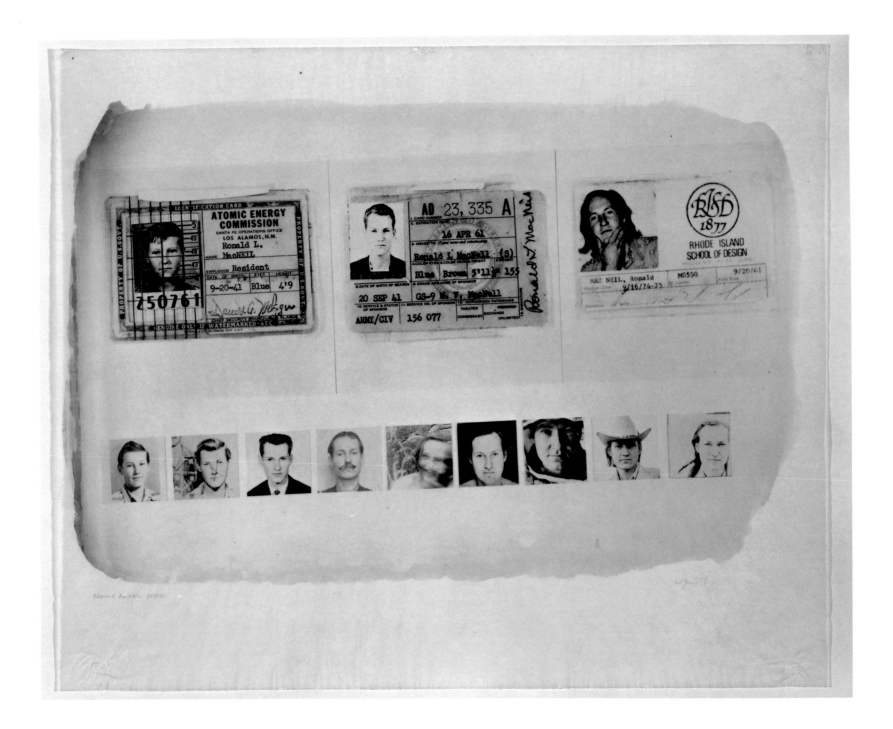

# John Pfahl

ower Places by John Pfahl continues his inquiry into the concept of the picturesque. The nearly complete series begun in 1981 now numbers some forty views. Power Places is by far his most complex effort, moving well beyond the visual puns and puzzles of the series Altered Landscapes and the scenic Picture Windows. Visually sophisticated and provocative, Power Places poses questions regarding many issues. In his analysis of the history of the landscape, Pfahl draws equally from painting and photography. As his models he has chosen from the revered, magisterial exemplars of painting as well as the hackneyed clichés of photography. In these thoughtful photographs, he freely assumes a purposefully traditional, even retardataire, approach to the landscape within a context addressing contemporary issues. He has literally appropriated historical, pictoral methodology for his paradoxical subject to underscore the controversial content. While adopting a postmodern strategy, reusing established stylistic formats, Pfahl continually alludes to nineteenth-century theory and criticism, which pondered similar problems relating to the rise of technology and its impact on nature.[1]

For his work in color Pfahl has established a conceptual framework, which sets it apart from the cloying views typical of much contemporary color photography. Color has always been used by him not just formally but in service to a strong fundamental premise.

The series Power Places did not proceed as an overtly political statement, instead Pfahl adroitly highlights in these pictures the problematic use of power in our culture. Rather than focusing exclusively on the controversial nuclear-powered plants, Pfahl chose to strengthen his statement regarding this complex dilemma by identifying a variety of diverse power-generating facilities, from hydroelectric and coal plants, to wind and solar stations.[2]

The series title suggests Pfahl's interest in the landscape and integration in it of industrial plants. It also alludes to the fact that some sites have been long associated with power, either as places considered by American Indians to hold spiritual power or locales favored by early-nineteenth-century painters for their particular beauty.

By posing power plants in idyllic settings and in compositions conveying tranquility and beauty, Pfahl employs an ironic stance and infuses tension into the group. He recognizes that in the tactical choice of selecting scenic, Edenic, or quaint names for power plants an impression of rusticity or perhaps Indian heritage is brought to mind. Names such as Peachbottom and Sequoia are examples of the efforts to ameliorate nuclear dread, making the plants sound like inoffensive suburban subdivisions.[3] Pfahl touches a nerve by showing the power stations more often than not masked by the land, especially in scale. The structures frequently appear as tiny silhouettes or small details on an expansive plane, somewhat lost in the scene. In these compositions he poses the rhetorical question: What is the effect of a plant that is barely visible?

*San Onofre Nuclear Generating Station, San Clemente, California,* 1981 (fig. 1), is the first in the series. In a sumptuous setting overlooking the Pacific, Pfahl questions the existence of such facilities in places of extraordinary beauty. The picturesque scene recalls Joel Meyerowitz's Cape Light photographs. Pfahl introduces, however, a subtle disquietude, not by the visual elements of the structures but rather by their significance. *Rancho Seco Nuclear Plant, Sacramento County, California,* 1983, is another sunset-suffused scene illustrating Pfahl's eclectic sources. Both images look more to calendars and annual reports than to art history for their origins.

Pfahl's series clearly reveals the similarity of debate and

Fig. 1.   *San Onofre Nuclear Generating Station, San Clemente, California,* 1981.

Fig. 2.   *Bruce Mansfield Power Plant, Ohio River, Pennsylvania, 1982.*

issues for nineteenth-century and contemporary artists, for progress in America has a history of threatening the environment and engendering controversy. The destruction of the wilderness by advancing civilization has been inextricably linked to American art and literature. Nineteenth-century painters, possibly less cynical about the future prospects of technology, nonetheless grappled with the dilemma.

In *Four Corners Power Plant, Farmington, New Mexico* (evening), 1982 (pl. 40), Pfahl successfully replicates in a barren, arid setting the quintessential luminist format, one closely associated with placid, littoral views. The horizontal composition, with its delicate pastels and deepening shadows, is a direct quotation from Martin Johnson Heade. A profound quietude and sense of the sublime predominates in the grandeur of nature. In many ways Pfahl's composition is the ideal landscape replete with spiritual overtones, except for the inclusion of the low silhouette of the power plant in the background. It is precisely by mimicking the venerated aesthetic that Pfahl perverts the concept of the ideal. Even though the structure is physically dwarfed by the vast wilderness, it cannot be ignored. Pfahl also presents an analogy regarding the issue of industrial progress to certain nineteenth-century views, for example George Inness's *Lackawanna Valley.* That pastoral view, though seen in retrospect as a charming, bucolic scene idealizing nature, celebrated the age of steam.

The same paradigm of high horizon line, simple composition, and aquatic marshes forms the basis for *Crystal River Nuclear Plant, Crystal River, Florida (evening),* 1982 (pl. 44). The emphasis is plainly upon the warm, textural grasses in the foreground and shift from dark to light between the reflective water and shadows. Pfahl's concern with mood and atmosphere is demonstrated in his exquisite handling of color and light. He locates the plant far back in the landscape, where it is apparent but not obtrusive. One reason for Pfahl's distance from the plants is simply that they are off limits, making it difficult to photograph them up close. More to the point though, he is interested in the relationship between the facility and the land and not just the plant itself.

In the wake of the events at Three Mile Island, the cooling towers of any power plant have become ominous symbols of nuclear disaster. Despite their attractive, refined sculptural form, the towers signify potential catastrophe. The implication of these forms, the intrusion of technology into nature, may be examined by comparing two photographs. Pfahl's setting for *Bruce Mansfield Power Plant, Ohio River, Pennsylvania,* 1982 (fig. 2), is a mirror image of Eadweard Muybridge's *Indian Village, Fort Wrangle, near Mouth of the Stachine River, Alaska,* 1868.[4] Both images are diagonally bisected by dark shores and vegetation. Muybridge's composition opens to reveal an encampment across a flowing river. Pfahl's photograph is essentially the same composition. Pfahl shows that the machine has invaded the garden, and it cannot be the same, regardless of the picturesque trappings and revered compositional models.

In the popular imagination Dutch windmills stand as romantic icons of a simpler, preindustrial age and also as ecologically sound devices for generating power. Pfahl observes, however, that they too are not without controversy. In *Windmill, Department of Energy, Boone County, North Carolina,* 1982, the light-suffused, bluish, rolling hills barely reveal the slender tower of the power-producing structure. In this image Pfahl reduces the landscape to a planar composition of overlapping bluish masses, beginning with the dark foliage in the foreground, moving back ridge by ridge to the clouded sky. The windmill is only slightly visible on the pinnacle of the mountainous terrain. The simple power device contrasts sharply with the sophisticated technology of other

plants. Yet this innocent windmill similarly was assailed by local residents.

Early photographs of the western territories have also served as models, although they tend to be more restrained and less lyrical in their portrayal of the landscape. His formal approximations of the familiar cause us to reconsider the virgin wilderness recorded by the topographic surveys. The allegiance to century-old landscape views is clear in the uncanny similarity of Pfahl's *Geysers Power Plant, Mayacamas Mountains, California,* 1983 (fig. 3), to Timothy O'Sullivan's *Kearsage Mining Company, Kearsage, California,* 1871.[5] With a similar plethora of monochromatic detail, that view, down into a valley and up to the opposite mountainside, is closely comparable with Pfahl's view. *The Geysers Power Plant* depicts an unusual power-generating facility. Here the scale is such that the earth-toned buildings blend into the golden California terrain. The flat plane and profuse details compress the view further to confuse the scale and enforce an awareness of the abstract composition. Unlike others in the series, the photograph is without a horizon or extremely deep space. Pfahl further stresses the abstraction, as the landscape comprises only two colors: ocher and forest green.

Pfahl utilizes contemporary as well as antique photographic models. *Niagara Power Project, Niagara Falls, New York,*

Fig. 3.    *The Geysers Power Plant, Mayacamas Mountains, California,* 1983.

1981 (pl. 48), typifies the abstract compositional strategies of formalism. The picture plane is divided into horizontal registers, beginning with the dark blue water at the bottom. In each layer a maze of lines breaks up the mass, accentuating the linearity and two dimensionality of the scene. Unlike the deep space in most of Pfahl's photographs, this view is tight, highly balanced, and planar. It is also meticulously executed. The high-tension powerlines form a metallic linear mesh similar to that frequent device, the chainlink fence. This image makes reference to the photographic heritage of examing industrial sites as landscape. A forest of electrical pylons and transformers forms a plane of serene geometric vegetation above the even green band of grass that laterally divides the composition. The cool colors of the apparatus are reiterated directly below in the linear grid of the channel wall. The rectilinear stratification of the earth combined with the vertical dynamite grooves renders the rock in a pattern akin to the lines of the electrical wires above. The depth of field seems slight, although it is not, for Pfahl has deceptively flattened the composition. He has removed all references to scale, reducing the image to its most abstract level. The linearity imbues the otherwise static arrangement with tension.

Cognizant of the philosophical tenets relating to landscape theory, Pfahl has employed light in a fashion consistent with the transcendentalists. In *Three Mile Island Nuclear Plant, Susquehanna River, Pennsylvania,* 1982 (pl. 43), he presents an innocent pastoral scene. Soft, even light bathes the sky and water in a pale yellow glow. The dominant horizontal elements, combined with the suffused, radiant light and sense of repose, refer to kindred compositions by John Frederick Kensett, Fitz Hugh Lane, and Martin Johnson Heade. Pastel colors abstract the towers so that they seem to have no more substance than their reflections mirrored in the water. Silhouetted branches stretching both upward and downward on the right dominate the foreground and inject a dramatic darkness to the otherwise still plane. This darkened foliage pointedly contrasts with the radiant background light. It is the jumble of branches that invigorates and introduces untamed nature, juxtaposing this large, irregular massing with the serene, templelike buildings across the water. The futurist structures are presented in a thoroughly idealized fashion. The reflections of the four sleek towers in the still water make

further associations with the concept of the sublime. They appear as symbols of civilization and religion, offering a utopian vision of the future and banishing the prospect of the apocalypse. By the classic simplicity of the architecture and serene landscape setting, the fulsome aura of Armageddon is forgotten. This is not to say that we are drawn into a specious, visual argument. Pfahl knowingly presents this brazen visual sophistry not in an attempt to dissemble but to display the complexities of the problem.

Although Pfahl's composition is consonant pictorially with those luminist representations of New England that promulgated the notion of the sublime through poised, quiet, harmonious arrangements of nature, his implication is quite different. Despite appearances, it is Edmund Burke's vision of the sublime, the awesome cataclysmic power of nature that is implied. Pfahl presents a pastoral idyll disturbingly contradicted by the prospect of the Dynamo.

In his multitude of power-generating facilities, Pfahl pays particular attention to the hydroelectric station. He finds a special significance in Niagara Falls, the familiar symbol of the grandeur and power of nature and America. *Ontario Power Plant, Niagara Falls, Ontario, Canada,* 1983 (pl. 42), conforms to Pfahl's paradigm of locating the plant in deep space so as to juxtapose its scale with that of the larger landscape. One must look closely to find the buildings, so utterly integrated are they into the cliffs. Dwarfed by the falls, the dark, horizontal structure appears rather small, eclipsed by the dramatic scale and power of nature.

Looking back as he has to photographic history, it was inevitable that Pfahl would record *Idaho Power and Light Plant, Shoshone Falls, Idaho,* 1984 (pl. 41). This work complements *Ontario Power Plants, Niagara Falls* while making conscious reference to Jackson's and O'Sullivan's views of Shoshone Falls. These two falls, nineteenth-century icons of the power and scale of nature, are now shown in harness.

In *Ginna Nuclear Plant, Lake Ontario, New York,* 1982 (pl. 49), Pfahl has virtually expunged all color from the image, allowing only a preternaturally yellow light above the horizon. Smudgy, dark clouds press down from above. A snow-covered foreground leads back into a dark orchard. The picture is bisected by a tall pole, centered above the naked branches of a small tree. The whole composition comprises silhouettes of trees receding into the background, where they commingle with high-tension powerlines. The waning light and dark shadows create a portentous atmosphere, a twilight of the gods. More than any other photograph, this image invokes the possibility of technological doom. Pfahl has economically assembled a highly dramatic, enigmatic scene in which nature dominates. Undeniable here is the influence of romanticism, especially Caspar David Friedrich's paintings with their mysticism, preponderence of dark silhouettes, and celebration of the cataclysmic power of nature.

The continued use of elementary compositions is evident in many Pfahl photographs. *Four Corners Power Plant, Farmington, New Mexico (morning),* 1982 (pl. 45), contrasts the prominent dark mass of rocks in the near foreground with tiny puffs of smoke along the far horizon. The plant itself is invisible, the outpouring steam the only evidence of its location. Pfahl's ironic wit interplays with his formal ordering of the landscape. He is well aware that the plumes read as smoke signals and are thus an atavistic reference to the Old West. The landscape is portrayed in extreme abstracts of darks and lights with minimal color. The empty open space, absence of details, and stress on scale heighten the immensity of the wilderness.

Formal compositional concerns, derived from models composed by Lee Friedlander and other contemporary photographers, reveal themselves in a number of works, such as *Palo Verde Nuclear Plant, Centennial Wash, Arizona,* 1984 (fig. 4). The strong diagonal bisection of the frame establishes the paramount pictorial elements of light and dark triangles overshadowing the plant in the distance. Similarly, the radiant branches of the tree in the foreground of *Indian Point Nuclear Plant, Hudson River, New York,* 1982 (pl. 47), establish the primary compositional format. The tree screens the view, putting into play a disjunction in scale between the branches and diminutive power plant in the distance. Here his emphasis, like that of the Hudson River painters who worked in that area, is on the majesty of the American landscape.

Continuing his investigation of the landscape and the picturesque, Pfahl focuses on the complex issues of power production. Cataloging the various types of facilities, he presents them more often than not as integral elements of the landscape. Pfahl also makes clear that, regardless of scale, the

Fig. 4. *Palo Verde Nuclear Plant, Centennial Wash, Arizona, 1984.*

symbolic function of the structures carries enormous weight. Borrowing stylistic formats from contemporary formalist photographers, nineteenth-century topographic photography, and even romantic painting, Pfahl slyly seduces the viewer with his appealing portrayals of technological progress.

NOTES

1. See Leo Marx, *The Machine in the Garden* (New York: Oxford University Press, 1964).

2. In his titles Pfahl uniformly identifies all power plants, clarifying which ones are actually nuclear powered.

3. Others include Beaver Valley, Big Rock Point, Catawba, Cherokee, Hope Creek, Humboldt Bay, Palisades, Pebble Springs, Wolf Creek.

4. See Weston J. Naef and James N. Wood, *Era of Exploration: The Rise of Landscape Photography in the American West, 1860–1885* (Albright-Knox Art Gallery, Buffalo; and Metropolitan Museum of Art, New York; distributed by New York Graphic Society, Boston [1975]), p. 178.

5. See Joel Snyder, *American Frontiers: The Photographs of Timothy O'Sullivan, 1867–1894* (Millerton, N.Y.: Aperture, 1981), p. 21.

PLATE 40

John Pfahl, *Four Corners Power Plant, Farmington,*
*New Mexico (evening)*, 1982

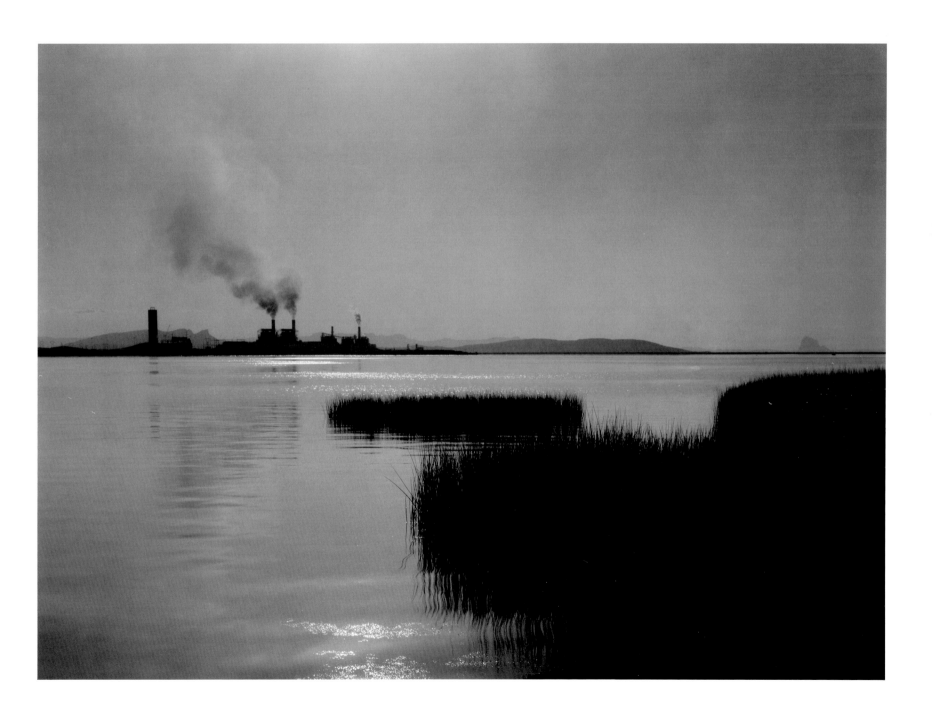

PLATE 41

John Pfahl, *Idaho Power and Light Plant,*
*Shoshone Falls, Idaho,* 1984

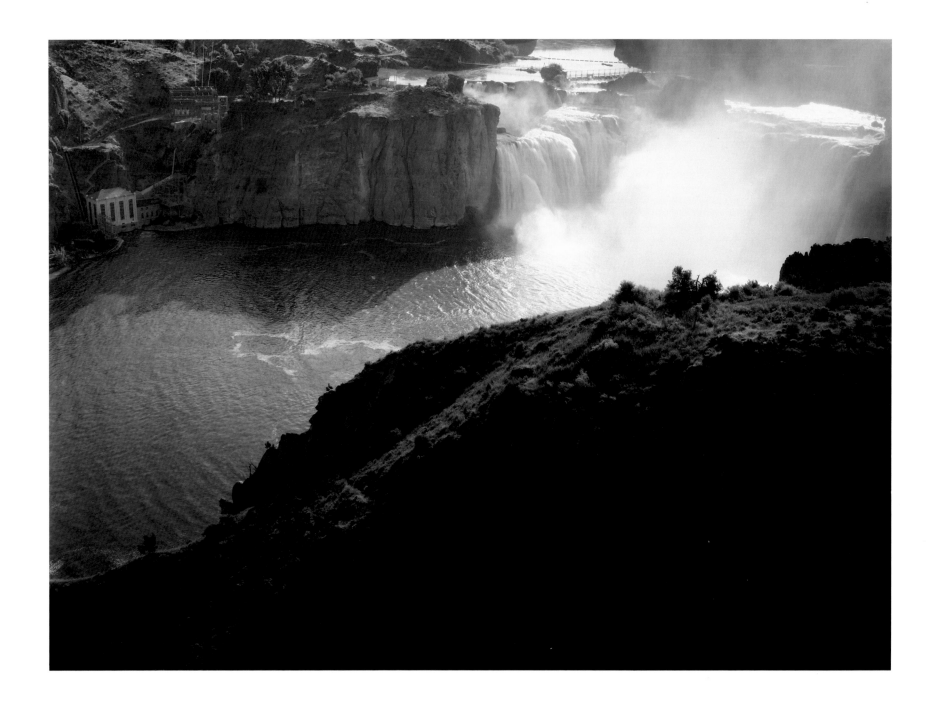

PLATE 42

John Pfahl, *Ontario Power Plant, Niagara
Falls, Ontario, Canada*, 1983

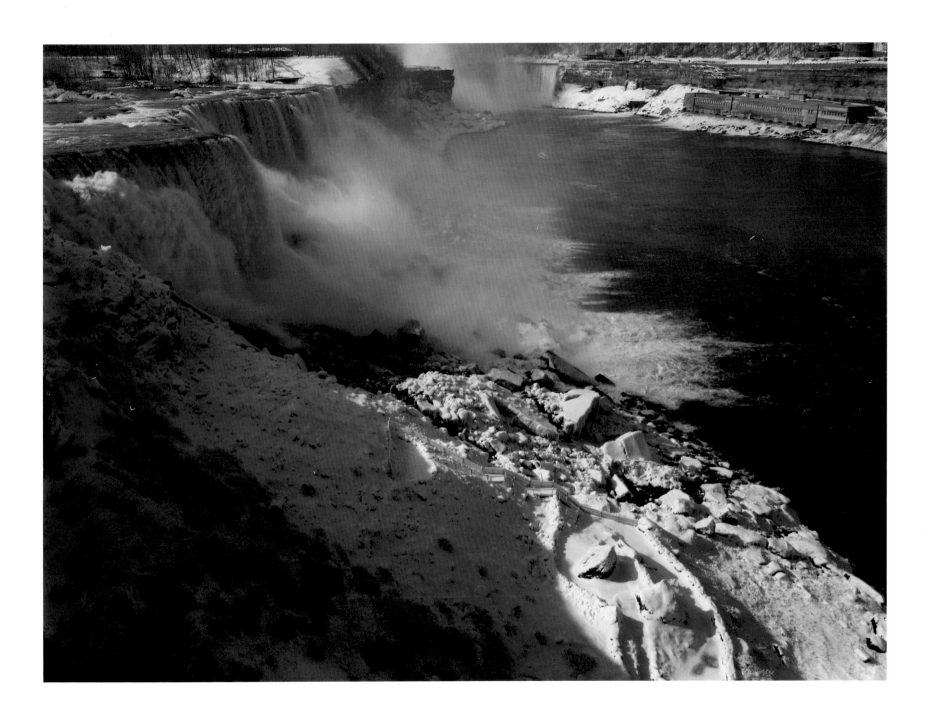

PLATE 43

John Pfahl, *Three Mile Island Nuclear Plant,*
*Susquehanna River, Pennsylvania,* 1982

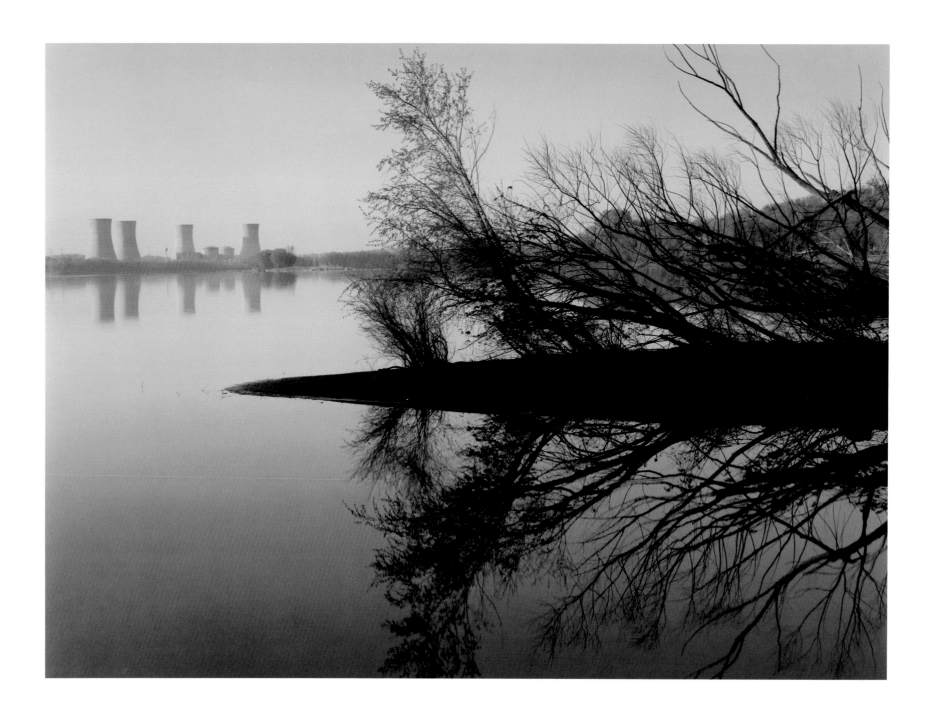

PLATE 44

John Pfahl, *Crystal River Nuclear Plant,*
*Crystal River, Florida (evening),* 1982

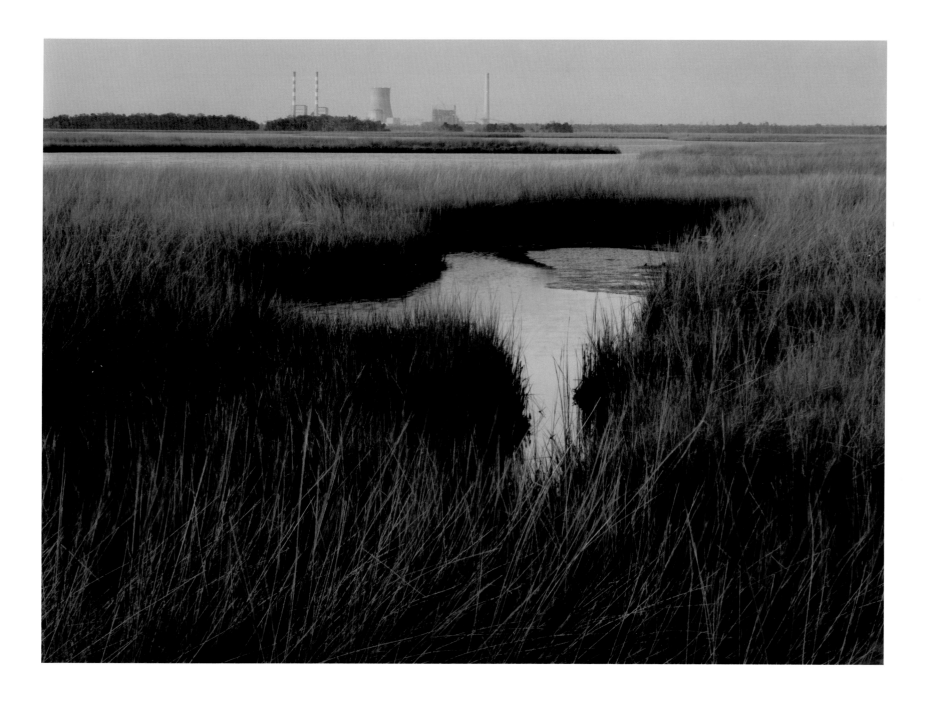

PLATE 45

John Pfahl, *Four Corners Power Plant, Farmington,
New Mexico (morning)*, 1982

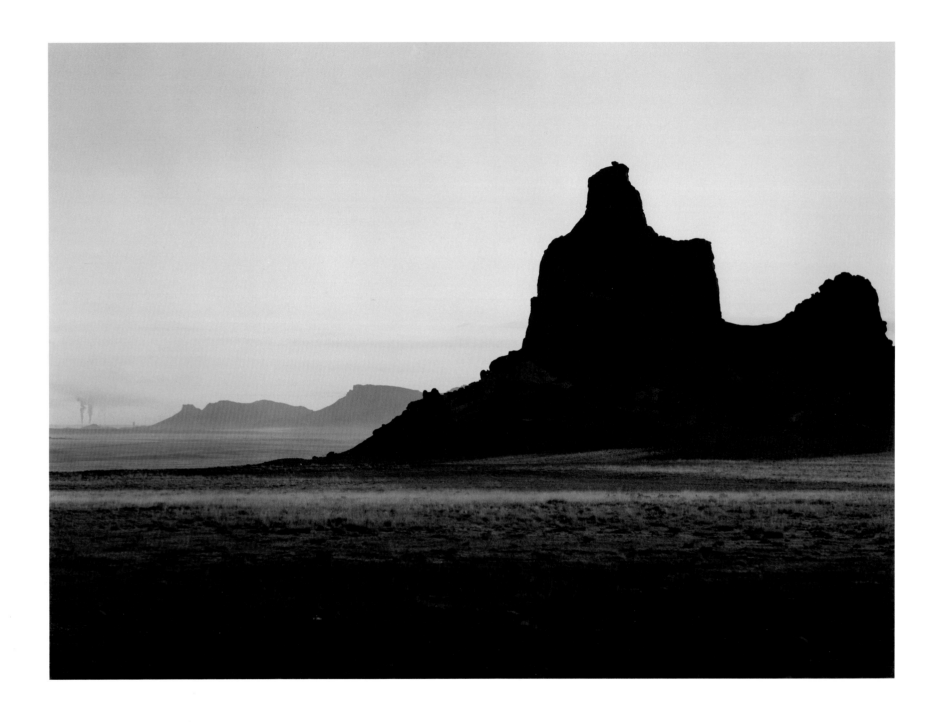

PLATE 46

John Pfahl, *Navaho Generating Station,*
*Lake Powell, Arizona (morning)*, 1984

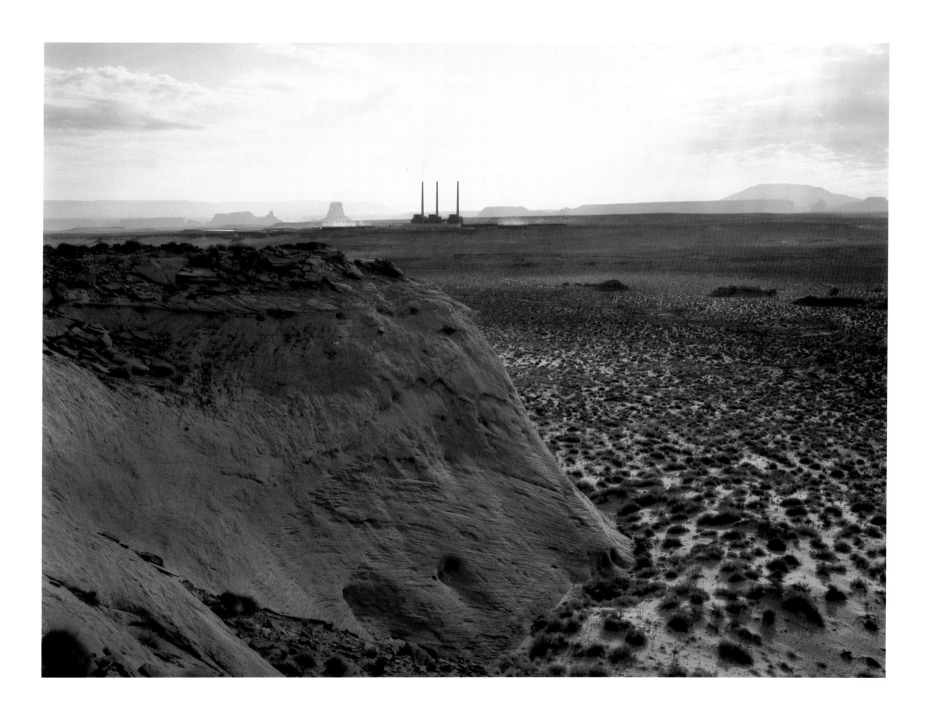

PLATE 47

John Pfahl, *Indian Point Nuclear Plant,*
*Hudson River, New York,* 1982

PLATE 48

John Pfahl, *Niagara Power Project,*
*Niagara Falls, New York,* 1981

PLATE 49

John Pfahl, *Ginna Nuclear Plant,*
*Lake Ontario, New York*, 1982

# Barbara Kruger

alter Benjamin asked in 1931: "Will not captions become the essential component of pictures?"[1] Fifty years later, Barbara Kruger's works seem to ideally realize his rhetorical proposition. While text combined with images is scarcely new, Kruger forges provocative works, joining terse, biting social commentary with strong, unusual images lifted from the public domain.

Perhaps more than any of the noted postmodernists using photography, Kruger has created a shrewd body of work, reflecting multifarious sources, scavenging details from constructivism to commercial advertising, from early cinema history to semiotics, from feminist rhetoric and Middle America colloquialisms. In borrowing images from the media, Kruger considers not only their appearance but their pre-existing meaning within the cultural, literary, or cinematic milieu. She explores the connotations of media-generated imagery and metonymic implications. She acknowledges in this choice of source material the utterly vast amount of information and visual imagery obtainable through these channels and the significance of apprehending imagery that has been informed by this sort of mediation.

As a graphic designer for Condé Nast publications in the 1970s, Kruger worked with typography, a signature component of her art, and gained a familiarity with imagery and didactic captioning specifically generated for the print media. Much like the visual material produced by the media, Kruger's works are very precisely fabricated with the spectator and possible interpretations in mind. All her works are formally untitled but for clarity are often referred to by the maxim emblazoned across the sheet, as they are here.

Scale is an important element in these works, and the six-by-four-foot images derive an uncanny power from the super-large presentation. At this size, the pieces are far more aggressive and confrontational than they appear in reproduction. Kruger's strident black-and-white schema is particularly effective. The simple, bold images she intentionally uses lend themselves to increased size. They often become more abstracted, with the dot pattern plainly revealed to contribute to the graphic quality of the image. The brusque images are so large and demanding that they exhaust the physical space of the gallery. Their provocative presence is further increased by the oversized typography recalling constructivist political posters and film posters. By using obviously media-generated pictures, Kruger forces the viewer to reconsider the whole class of objects and imagery that are known from these sources. She refers to visual strategies and formats that are culturally understood, thereby allowing an iconographic reading of the photograph.

The signature red enamel frame escalates visual dynamism, further compounding the jarring effect of the work. The vivid, colorful perimeter around each work blatantly contrasts with the austere black-and-white imagery. Furthermore, when set against the white gallery wall, the frames introduce the only color. Not some mere decorative device, the frames are an integral component, intensifying the presence of each piece. Furthermore, the unique frames clearly set Kruger's works apart from others and illustrate as well her thoroughness in borrowing stylistic details from early modern art.

Recently Kruger has again expanded the scale of her pieces, constructing monumental triptychs, between ten and twelve feet high and eight feet wide. Towering over the viewer (fig. 1), the works are transformed into even more powerful declarations, for the staggering size further increases both the intensity of the work and validity of the maxim.

Confrontational and interactive, the captions blare out at the viewer. Kruger's slogans are unequivocal absolutes. Speaking so emphatically, they require an individual abnegation from the viewer, denying their complicity. The works are exemplary of Allan Sekula's observation that "messages sent into the 'public domain' in advanced industrial society are spoken with the voice of anonymous authority and preclude the possibility of anything but affirmation."[2]

The unsettling presence of the works is derived in part from their location in a gallery context. Standard billboard typography, imagery, and scale are now commonplace means of public address. The billboard is easily dismissed as an insignificant familiar element of the urban landscape; or, as John Berger notes, ignored because we have become so accustomed to being addressed by it.[3] Within the neutrality of the gallery space, however, the arresting slogan and imagery of the large-scale work is provocative. Berger further observes the transformation of the "spectator-buyer."[4] Kruger suggests

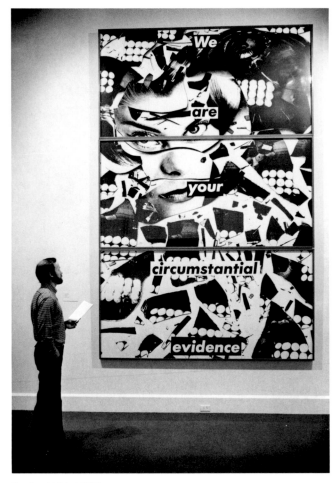

Fig. 1.   *Untitled*, 1983.

the norm for the appearance of everything.[5] For this reason Kruger prefers generic images. Furthermore, in recycling reproduced images, she acknowledges their original existence and cultural connotations. The manifold implications of the images are an essential component, as photographs depend on their ability to communicate through association with a cultural definition and implicit text.

During the mid-1970s, Kruger began to move away from painting. By 1978 she was using text with photographs, first separately, then superimposed over the image. Kruger's single words grew into bold slogans that were variations and corruptions of familiar maxims and old saws. She also invented new biting apothegms. While she used the common expression, "Money can't buy me," she also expanded it with her own inverse corollary in the work *I am all that money can buy.* The captions are reminiscent of various societal instructions from fortune cookies to biblical shibboleths. They are precisely crafted, terse, and exacting; or, as Kruger aptly puts it, "with no flab." They have a very intentional ambiguity purposefully allowing multiple interpretation while diminishing a narrower, didactic attitude. Kruger states, "We loiter outside of trade and speech and are obliged to steal language. We are very good mimics. We replicate certain words and pictures and watch them stray from or coincide with your notions of fact and fiction."[6]

Kruger builds her pieces on accepted semiotic codes. In "The Photographic Message" John Barthes notes: "The text loads the image, burgeoning it with culture, a moral, an imagination" precisely as do Kruger's maxims. Barthes also writes: "The text constitutes a parasitic message designed to connote the image, to 'quicken' it with one or more second order signified," and observes that the text now combined with the photograph is in fact a historical reversal, where the image no longer illustrates the words but the reverse.[7]

Kruger toys with that symbiotic interaction between language and image. Her captions are the principal focus because they recontextualize the photographs. To read the work, the interrelationships and connotations of the caption and image must be analyzed. Kruger exploits our cultural response to the familiar advertising format. Instead of neutral statements simply endorsing a product, we get a bald, accusative motto, one that demands an interactive response. Her

this too by transporting that mode into a wholly new arena, propositioning the gallery viewer as a consumer. She freely corrupts the magazine photograph in much the same manner that advertising photography co-opts painting models.

Kruger's work is based on magazine photographs published since the 1920s. Using details or entire images, she enlarges them to enormous size. By appropriating extant images and locating them in a wholly different context, Kruger builds on the familiar visual vernacular. Fundamental to her work is the premise that the photograph has now so thoroughly conditioned the viewer that it in turn has become

declaratives require either an accession or rebuttal. At the very least, the pieces prompt a memory scan for the visual or literary sources invoked. Clichés and hackneyed sayings have been transmuted into blunt accusations commenting on society, commerce, power, and interpersonal relationships. The power of the texts is supported by the scale and clarity of the typography. Exhorting the viewer, these massive photographs are contemporary social agitprop for which the message is the medium. The formal elements of Kruger's pieces, furthermore, tend to support such a function. They are an exemplary "synthesis of ideological and formal aspects" such as Aleksandr Rodchenko proposed. The bold dramatic and simplified sans serif lettering of these broadsides has its heritage in the graphic work of el Lissitzky and Bauhaus typography of Herbert Bayer's work.

Kruger has been called a "guerrilla semiologist."[8] The polysemies of Kruger's you expand the boundaries of the works, cutting them away from narrow meanings and polemics. The use of personal pronouns makes these interactive works: you individually, we collectively; or you and I and society at large are invoked. The works directly question our responsibility. Kruger does not castigate some nameless, impersonal, and unidentifiable they over whom we have no control. She does not distance herself or her audience from accountability. It is not a nefarious and unresponsive they but you. Curiously, Hal Foster identifies the you as "a Big Brother who rules but is mystified";[9] nor does he identify the you as being principally male as have other writers. Title labels such as *I will not become what I mean to you, I am your immaculate conception, We are all that money can buy,* and *We will no longer be seen and not heard* make it difficult to overlook the apparent gender politics of these pieces. In linguistics the words *you* and *I* are identified as shifters because they allow the speaker to shift from code to message, from collective to individual, from impersonal to personal, continually changing places and referents in speech, although the you is never I. Power shifts as well, as it is not seen in "fixed things: but rather exists, and hides in representations."[10]

All these aspects, the ideological, interactive accusation and avant-garde sources, are present in *You profit from catastrophe,* 1984 (pl. 56). Here Kruger uses Rodchenko's worm's-eye view, which, when combined with the severely cropped

enigmatic image, establishes a strong abstraction. The image is cinematic, recalling Sergei Eisenstein's effective close-ups and political commentary. The bloated hand, coarse, grainy dot pattern, and strident black-and-white tones further contribute to the abstraction. Kruger uses camera angles and cinematic clichés to impute the notion of power. The casual cigarette, the finale to some conspiratorial deal making, is the central gesture of the image. That action, coupled with the dramatic diagonal caption and placement of the hand, enlivens the image but also underscores the use of the present tense and personal pronoun in the text: "You profit." The viewer is not simply informed but becomes directly involved by the choice of pronouns. Kruger's slogans suggest some basic capitalist tenets of profit, money, and power and also calls into account our ethics at the misfortune of others.

Not only does Kruger exploit the media-derived image, but she transforms those familiar elements into fraudulent advertisement, one announcing something quite different. This translation of the original photograph image into a polemical tool has clear antecedents in the cynical montages of John Heartfield, Hannal Hoch, and others who used the photograph image for social and political commentary in the 1920s and 1930s.

*Perfect* illustrates Kruger's work around 1980 and contrasts with her current dynamic pieces, in which typography is screened over a square photograph. The extremely grainy tonalities and balanced, static, truncated figure contribute to a sense of repose. The clasped hands held before the demure sweater neckline further underscore feminine gentility and a personification of roles.

Kruger sharply distinguishes male and female roles. *We have received orders not to move,* 1983, for instance, depicts the silhouette of a seated woman, pinned against a background, clearly identifying the subordinated female as We. Conversely, she poses the male in the dominant role in *You make history when you do business,* 1983 (fig. 2). Preponderantly, the You refers to the male role, as in *You molest from afar,* 1982, or *Our time is your money,* 1984. Throughout the works there is the undeniable tension of male and female stereotypes. By association, the slogans examine the politics of gender, especially as they are presented through the media. The abstracted details of women–hair, hands, hairbrushes–commingled with

the litany of captions confirm the feminist tack: *We will no longer be your favorite disappearing act, We refuse to be your favorite embarrassments, We will no longer be seen and not heard, I will not become what I mean to you, We are your circumstantial evidence.* Kruger states, "I see my work as a series of attempts to ruin certain representations, to displace the subject and to welcome a female spectator into the audience of men."[11]

*We are being made spectacles of,* 1983 (pl. 53), follows in this

Fig. 2.    *Untitled,* 1983; silver print; 72 x 48 in. Collection of the artist.

vein. A man embraces a woman, he leans over her shoulder, above her, subordinating her. Kruger expunges the romantic by segmenting the image with six horizontal bars. More significant than the formal action of the type is the juxtaposition of the visual and textual content. Here Kruger poses a variation of the argumentative statement, "I refuse to be made a spectacle of." By using the word *We,* Kruger suggests instead a pervasive condition, a generality, explicitly citing the refusal of many and indicting the societal norm.

Kruger draws from the stereotypical presentation of women in the media, an issue that has been probed by a range of authors. In an examination of advertising photographs, Erving Goffman discusses the portrayal of male and female relationships, analyzing the institutionalized depiction of the subordination of women.[12] John Berger too has put forth a number of salient observations regarding the female role: "To be born a woman has been to be born, within an allotted and confined space, into the keeping of men. . . . Women watch themselves being looked at. . . . *Men act* and *women appear* [Berger's italics]" (or as Kruger puts it, *We refuse to be your favorite disappearing act*). Moreover, Berger concludes that a man's presence is dependent upon the promise of power which he embodies, "but the pretense is always toward a power which he exercises on others."[13] Kruger carries his point in such works as *You make history when you do business, You molest from afar, We are your circumstantial evidence.*

Discussing the relationship between the stereotype and gender in Kruger's work, Craig Owens notes: "Stereotypes treat the body as an object to be held in position, subservience, submission; they disavow agency, dismantle the body as a locus of action and reassemble it as a discontinuous series of gestures and poses–that is, a semiotic field."[14] This is clearly borne out by Kruger's works addressing the stereotypical role of women. The fracturing of women is seen in two other monumental triptychs. In *We construct the chorus of missing persons,* 1983 (pl. 55), one of Kruger's most enigmatic works, the hidden woman behind the veil of long hair exists but is invisible, a nonentity. Kruger depicts the individual, wholly subordinated to the stereotype or to a more dominant partner, allowing only a faint version of the original to be discerned, the rest, the persona, is missing. Moreover the words *the chorus of* are plastered over the mouth as a gag, rendering her

silent and inert. She is neutralized, a prisoner behind the bars carrying the slogan.

Similarly, *We are your circumstantial evidence,* 1983 (pl. 54), one of Kruger's largest works, presents a graphic montage of a shattered image of a woman. The type is derived from fashion magazines and casts an image so idealized as to represent no single woman but only the empty stereotype. The recurrent groups of ambiguous white dots echoing throughout the image may be pearls, beads, jewelry, or pills: accoutrements of the fashionable life. The eyes of the model seek our own, but she is a captive within the artificial and fashionable milieu of the original image. As mere physical property or facts, she represents an entity that has become just circumstantial evidence of a relationship.

The banality of the images exhorts a scrutiny beyond the apparent visuals to their meanings. Kruger often forces us to focus on the details of familiar objects through the close-up. The enlargement not only renders details more clearly but also discloses a whole new structural formation of the subject. Kruger uses this familiar cinematic device expressly to increase dramatic tension and heighten impact. Potentiated by monumental scale, the results are arresting as in *Surveillance is your busywork,* 1984 (pl. 58). Departing from the rectilinear format, the work is among the most sinister primarily by virtue of the text but also because of the large disturbing face. Set against a shadowy background, the head with squinting eyes and slicked back hair peers out over the viewer. While the figure in fact may be a scientist or scholar looking though a loupe, the icon is more legible as a cinematic cliché representing a nefarious character or Big Brother. By cropping any contextual references, Kruger obliges us to examine known models from print and film media. Unlike the pieces with seemingly contradictory text and image, here the bold diagonal labeled "surveillance" wholly compounds the tone and content of the photograph. The harsh lighting from below accentuates the contrast in the strident black-and-white composition. Devoid of personalizing details in the massive blowup, the abstracted face additionally supports the intimation of some sinister activity.

Moreover, the word *surveillance* is itself loaded and engenders only pejorative connotations, invoking ominous, mediated recollections of espionage, secret police, constabu-

lary examination, and detectives. As with certain other works, an indictment of governmental activity, as well as individual machination, is drawn.

*Surveillance* is additionally related to other pieces produced in 1984 that address seeing, such as *What you see is what you get, Your seeing is believing,* and *You are giving us the evil eye* (pl. 50). The latter piece pointedly refers to the history

Fig. 3. *Untitled,* 1983; silver print; 72 x 48 in. Private collection.

of art. The depicted passage mentions vision and memory, two elements fundamental for a reading of Kruger's work. Piling up illogically down the page are the words *motion, spectator, picture, legitimacy, impressionism, eye, articulate, beauty.* By scattering the caption over the page, Kruger insists that the viewer scan the text. Additionally, Kruger alludes to the well-known photograph by André Kértész, *Mondrian's Glasses.*

When these works are read cumulatively, the portentous implications in each piece are corroborated and intensified. In *Your manias become science,* 1982 (pl. 51), Kruger pointedly criticizes military power. Set low across the work, the slogan is placed before a reproduction of the mushroom cloud of an exploding nuclear bomb at Bikini Atoll. Barely visible along the bottom are tiny battleships dwarfed by the blast. A relatively small work (40½ x 49½ inches), it holds its own even when adjacent to larger works, owing to the gravity of the statement and enormity of the image. Kruger offers a contemporary apothegm as a warning. Her suggestion that scientific enterprise may stem from maniacal sources has a renewed credibility, given the possibility for future space weaponry. *Your fact is stranger than fiction,* 1983 (fig. 3), and *Progress is your most important product,* 1984, further attest to her assessment of technological society, much like the commercial adage "better living through chemistry." The implied and unstated commentary questions the important products or effects of our culture.

A number of works from 1984 focus on money and power. *Your money talks, Our loss is your gain,* and *You are getting what you paid for* are all corruptions of colloquial phrases and sayings. Also from 1984 is *Money can't buy me* (pl. 57), a stiking ten-foot triptych. The grainy dot pattern throughout reaffirms the newspaper origins of the imagery. The looming gun and massive faces, energetically montaged with the shattered glass in the lower right, look to film vocabulary. This group goes to the heart of society calling into account basic motivating levers, whether in business or interpersonal relationships. The historical actuality of the imagery supports Kruger's critique of prevailing societal attitudes.

By using media-derived images from which can be recognized various connotations, Kruger confronts the pervasive visual language of our culture. Saturated as we are with advertising, we have become cognizant of the stereotypes and emblematic portrayals of people, products, concepts, and attitudes. Kruger uses the visual lingua franca to question fundamental societal values and roles. She uses signs and symbols, subverting them to express her narrative while challenging the viewer.

NOTES

1. "Walter Benjamin's 'A Short History of Photography,'" trans. Phil Patton, reprinted in *Artforum* 15 (February 1977): 51.

2. Allan Sekula, "On the Invention of Photographic Meaning," in *Thinking Photography,* ed. Victor Burgin (London: Macmillan Press Ltd., 1982), pp. 84–85.

3. John Berger, *Ways of Seeing* (London: British Broadcasting Corporation and Penguin Books Ltd., 1972), p. 130.

4. Ibid., p. 134.

5. William M. Ivins, Jr., "Prints and Visual Communication," in *Photography in Print,* ed. Vicki Goldberg (New York: Touchstone Books 1981), p. 391.

6. Quoted from *Documenta 7* (Kassel: D & V Paul Dierichs [1982]), 1: 286. See also Jane Weinstock "What she means, to you," in *We won't play nature to your culture* (Institute of Contemporary Arts, London, and Kunsthalle, Basel, 1983), p. 16.

7. John Barthes, "The Photographic Message," trans. Stephen Heath, in *The Camera Viewed: Writings on Twentieth-Century Photography,* ed. Peninah R. Petruck (New York: E. P. Dutton, 1979), 2: 196–97.

8. Weinstock, p. 13.

9. Hal Foster, "Subversive Signs," *Art in America* (November 1982): 89.

10. Craig Owens, "The Medusa Effect or, The Specular Ruse," *Art in America* 72, no. 1 (January 1984): 98.

11. Quoted from March 1984 press release prepared by Annina Nosei Gallery, New York.

12. Erving Goffman, *Gender Advertisements* (Cambridge: Harvard University Press, 1979).

13. Berger, pp. 45–47.

14. Owens, p. 100.

PLATE 50

Barbara Kruger, *Untitled*, 1984

PLATE 51

Barbara Kruger, *Untitled*, 1982

PLATE 52

Barbara Kruger, *Untitled*, 1983

PLATE 53

Barbara Kruger, *Untitled*, 1983

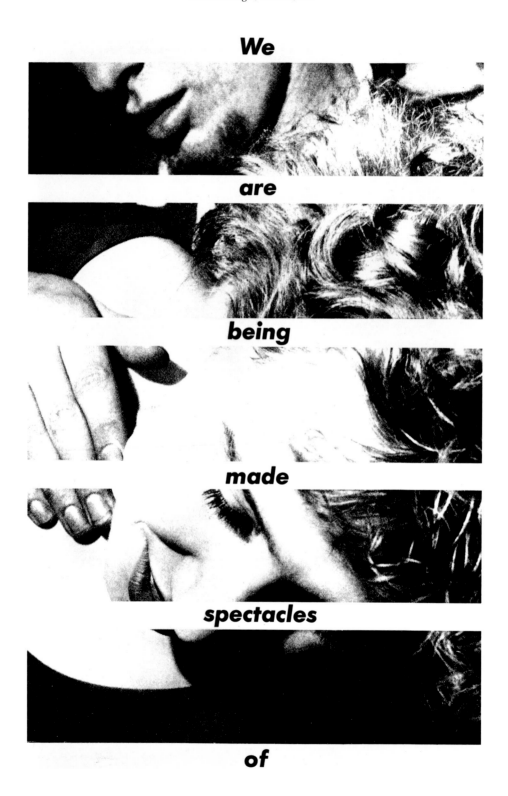

PLATE 54

Barbara Kruger, *Untitled*, 1983

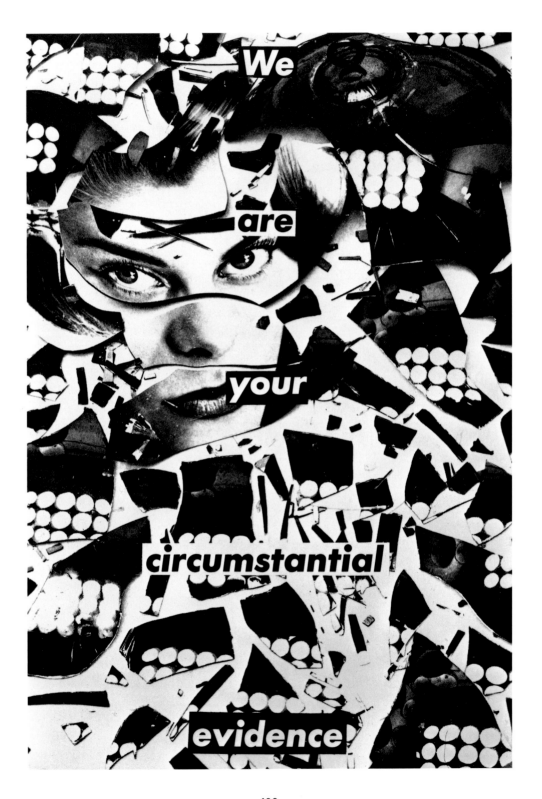

PLATE 55

Barbara Kruger, *Untitled*, 1983

PLATE 56

Barbara Kruger, *Untitled*, 1984

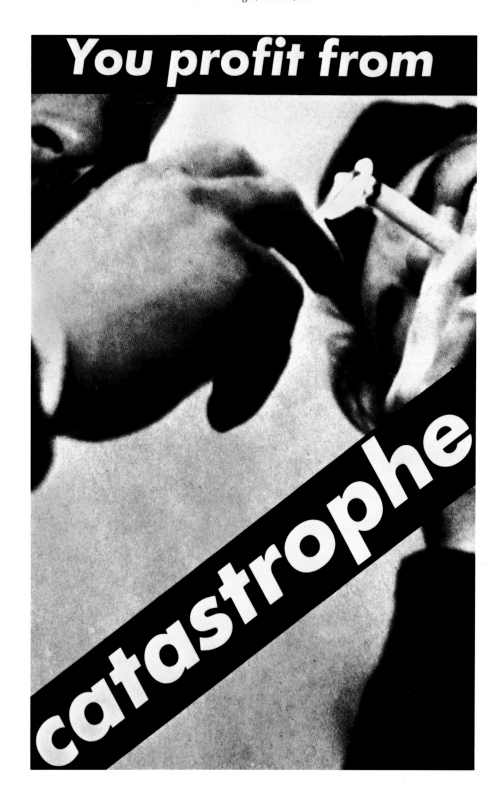

PLATE 57

Barbara Kruger, *Untitled*, 1984

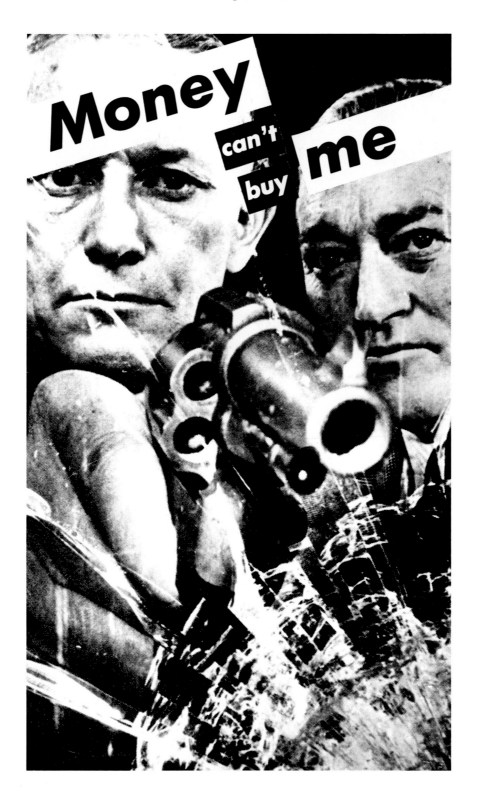

PLATE 58

Barbara Kruger, *Untitled*, 1984

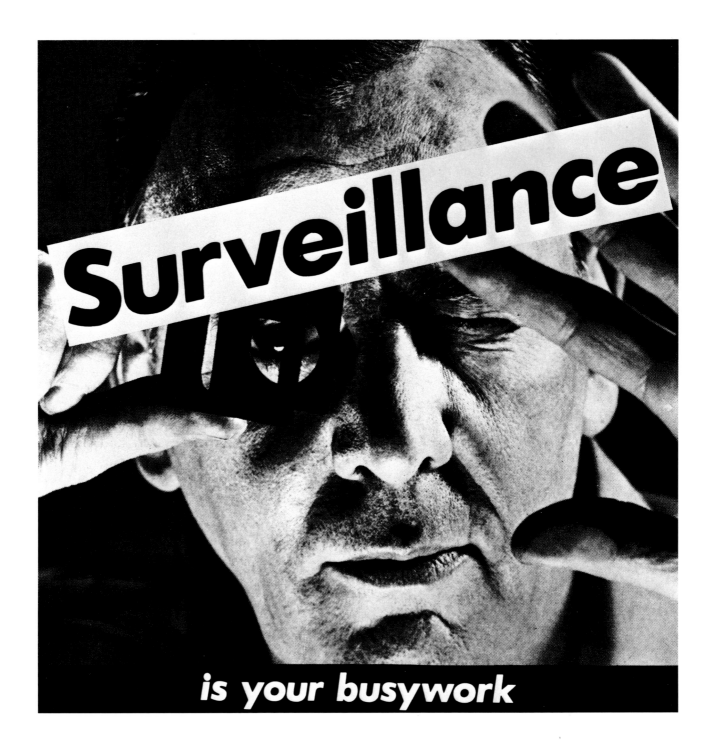

# Eileen Cowin

In her photographs Eileen Cowin intertwines reality and illusion, truth and artifice. She locates her examinations of interpersonal relationships in contrived settings, from the breakfast table, to the bedroom, to empty, darkened rooms. Cowin places options before her audience, allowing the viewer to supply the appropriate dramatic solution and dynamic to an interpretation of the image. Her photographs recall the device of a now-dated personality test in which the subject is asked to develop appropriate stories for a number of highly ambiguous pictures.

Cowin provides a rather unusual glimpse of the nuclear family. Her photographs may also be construed as records of a long-running, albeit intermittent, performance exploring the psychodynamics of mundane situations in American domestic life. Her scenes are not the customary, mannered, frozen photos but are instead enigmatic confrontations. Usually, familial tensions are suppressed in formalized sittings and casual snapshots for which love, contempt, and envy are withheld from view.[1] Cowin is aware that any portrait is, as Erving Goffman notes, merely the pose–a decorative representation of oneself–that is assumed for the camera. Unlike the harmonious record family photographs document for posterity, Cowin's images are closer to the contemporary media portrayal. While recognizing that each family is, of course, different, Cowin observes that there is nonetheless, a universality in the type of interaction, which accounts for the resonance of her stereotypes.

Cowin's series of photographs on the contemporary family began in the fall of 1980. The series, although seemingly a startling new direction for her, is the product of a logical progression. A series of Polaroid photographs begun in 1976 and a subsequent series, One Night Stands, specifically focused on interpersonal relationships, in a narrative format utilizing constructed arrangements fabricated solely for the camera. In fact, for well more than a decade almost all of Cowin's work has been made in the studio. Reacting to the many formalist still lifes pervading photography in the late 1970s, Cowin had turned to tableaux that had a human element and emotion, images that questioned relationships and the domestic domain.

Contrary to perceptions, Cowin's photographs are not autobiographical. In them she seeks to uncover the interpersonal dynamics of a couple and a family. The scenes simultaneously seem related to factual, documentary photography and the fictional soap opera, slyly revealing the pedestrian with uncanny clarity. Although diaristic, they refer not to her family but to a stereotypical family. The scenes are of the familiar family unit–mother and father, son and daughter–in which Cowin attempts to portray the American family and their relationships.[2]

The couple has been a primary component of Cowin's work since 1976. Within the domestic milieu or outside of it, the idea of relationships continues to absorb her attention. From the outset of the series, the couple, as in *Untitled*, 1980 (fig. 1), is portrayed romantically, despite distractions and lack of privacy. Cowin repeatedly used the dance as a motif symbolizing the dynamics and complexity of a relationship as well as the intimacy and emotional tension shared by two individuals. The man in his tuxedo dances with the woman who is dressed not as he is, ready for a night on the town, but rather in house clothes. Nonetheless, in a blend of fiction and reality, the couple dances in embrace amid the clutter and distractions of domestic life.

In response to efforts to categorize her photographs, Cowin for a time used the term *family docudramas*. She never felt, however, that the appellation accurately described her work and eventually rejected it, since the tableaux were not records of actual incidents. Cowin's pictures, as she says, are not *of* situations but rather *about* them. They do not document scenes but illustrate emotions, conditions, problems, and typical interactions of a family. Cowin utilizes ritualized scenes and expressions, employing types that have been simplified and standardized in the conventions of mass media. She repeatedly poses the ambiguity of reality against the apparent truth of fiction.

The photographs are conceived with an audience in mind. Each scene is planned for its readability or effect for the imaginary voyeur. This intentional affectation discloses a fundamental association between theater and Cowin's work. She is compressing the narrative, interaction, plot into one dramatic moment. The situations portrayed by Cowin are so open and equivocal that the viewer is obliged to supply the context. Cowin pointedly offers few clues and scant information about her situations. Indeed, she studiously avoids any

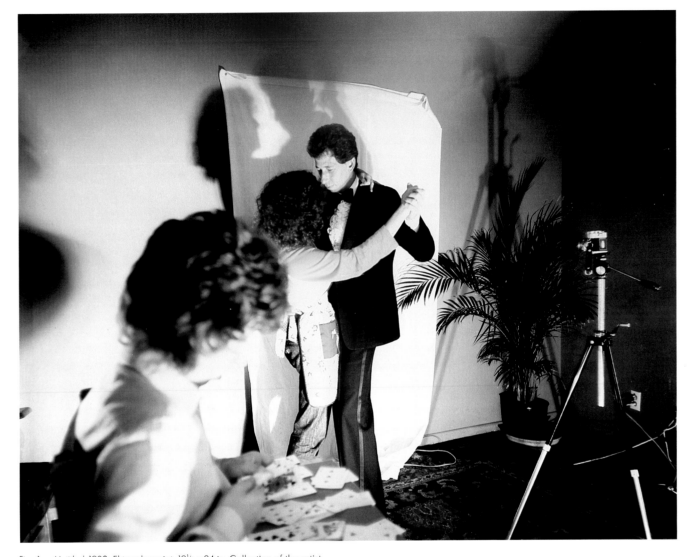

Fig. 1. *Untitled*, 1980; Ektacolor print; 19⅛ x 24 in. Collection of the artist.

labeling, intentionally setting up the possibility for divergent, multiple interpretations, and identifies the works simply and uniformly as untitled.

Each picture evolves slowly as Cowin carefully plans the mise-en-scène and makes sketches considering every element. She gives scrupulous attention to the arrangement of the figures, the gestures, the postures, the interaction, scale, camera location, shadows, lighting, color. Her scenes refer to theater in the apparent, slightly awkward staginess. No seamless perfection is sought. The stark interiors with their bald backdrops and minimal furnishings are like sets for the dramas she casts.

In some images Cowin examines relationships amidst the dissolution of the modern marriage. She explores family tensions and the difficult moments in raising children, as in *Untitled*, 1983 (fig. 2). Discussing the portrayal of the family, Julia Hirsch notes that despite the exploration of intimate relationships in candid photography and wide acceptance of pictures of naked parents and children and sexually curious siblings, photographs of marital violence, family strife, and dislocation are avoided. Formal photography similarly ignores the statistics of adultery, divorce, mental breakdown, and juvenile delinquency.[3] Here with a few facial expressions Cowin alludes to the forgotten familial episodes of silence and tensions that we have all experienced. The impact of marital change, parental replacement, and transitory relationships on children is suggested in *Untitled*, 1981 (fig. 3). While other interpretations are, of course, entirely possible, Cowin has acknowledged that departure and separation have been the focus of some of her works.[4]

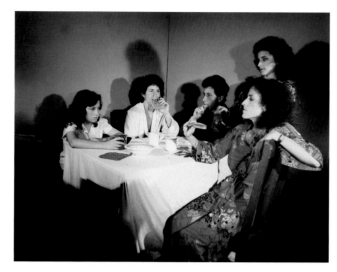

Fig. 2.    *Untitled*, 1983; Ektacolor print; 18½ x 24 in. Collection of the artist.

The recent photographs comprising the exhibition are rather different from Cowin's better-known images. In addition to the change in medium and increase in scale, she has eliminated all but the most essential. In ridding her composition of an assortment of props, Cowin comes to grips with the emotional tension of her pictures. The interpretation now relies upon a simple gesture, pose, or glance. Furthermore, Cowin exploits the stark setting to contribute to a dramatic sense of isolation, confrontation, or anxiety. Her shift from the domestic setting, with its greater realism, to the darker voids exercises a profound psychological effect on the context.

Cowin now scrutinizes the individual. Excerpted from the security of the domestic setting, the figures become more introspective. The solitary figures do not, however, seem vulnerable or static but rather are shown in reflective moments of calm between events or activities.

Since the beginning of the series Cowin has acknowledged the influence of Edward Hopper and George Segal, and newer works in particular reveal their effect. In the ordinariness of their subjects, pedestrian situations, and sense of quietude Cowin's photographs recall their work. The psychological portrayal and self-contained emotion too are similar.

Cowin's family photographs have always incorporated stagy, dramatic lighting. Strong cast shadows, a traditional cinematic device underscoring the tension of a scene, are used principally to emphasize the emotionally charged dynamic relationships of her characters and establish the fictitious nature of her settings. Recent works in their severe pictorial economy make more copious use of intense lighting. The spare, illuminated subjects contrast with the massive, darkened background void, emphasizing the solitude of the figures.

In *Untitled*, 1983 (fig. 4), Cowin alludes to the ambiguity of relationships. From soap operas and other contemporary potboilers, we are conditioned to read this scene—with the telephone and sidelong glance—in terms of an illicit relationship, despite any evidence to support such an interpretation. The psychological edge of the image rests precisely on its ambiguity and allegiance to the established conventions of theatrical romance.

Although central to the family series, the couple attains a special prominence in Cowin's recent pieces. Focusing on the isolated man and woman, chiefly in black and white, Cowin now examines the interaction and dynamics of the adult relationship. No longer parents amidst children, her man and woman are placed in a dramatically minimal setting. Perhaps more than others, these refined images reflect the influence of cinema as the source for her pictorial strategies.

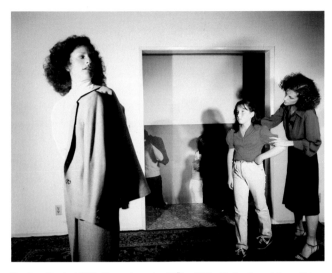

Fig. 3.  *Untitled*, 1981; Ektacolor print; 18⁷⁄₈ x 24 in. Collection of the artist.

During the past five years Cowin has shot in black and white as well as color, but these images have rarely been printed.[5] Her few four-by-five-foot black-and-white prints have occasionally been incorporated in her color images as in *Untitled*, 1981 (fig. 3). The murals tend to loiter in the background, casually propped against a wall, reinforcing the narrative and also serving as flashbacks or means to amplify the primary narrative. Consistently simpler in composition than her contemporaneous color images, they have fewer competing elements and a heightened theatricality. The newer black-and-white prints fully exploit the potential of that medium to serve the dramatic atmosphere of the scenes.

Cowin has alternatively used empty, restrained settings and those with a plethora of domestic props.[6] The use of props to establish a context originates virtually from the inception of portraiture. There is a similarity between Cowin's assemblage of domestic stuff and the variety of props found in nineteenth-century portrait studios. Props are put to the same use: to establish a visual facade. Cowin, however, does not select objects that elevate the status of her subject but rather chooses objects emblematic of middle-class values. Her most recent images tend to be more parsimonious, with virtually all but the most critical elements eliminated.

The nuance of gesture and effect of a dark, empty frame

create the dynamics in *Untitled*, 1984 (pl. 62). As a melodramatic device, the scene carries a degree of gravity and finality. The act of leave-taking is examined as part of interaction. The high graphic contrast further accentuates the emotional potential. The outstretched arm and beckoning fingers of the woman follow the departing man, barely visible in the background. Her face is hidden in shadow, as is the man: the image is entirely carried by the slightest of gestures.

In other black-and-white images of the couple, Cowin uses the pictorial vocabulary of film paying homage to the conventions of the medium. An extreme close-up, *Untitled*, 1984 (pl. 59), with all details but the heads and hand obscured by strong shadows, is particularly ambiguous. Although the characters' expressions are neutral, the use of the close-up implies a highly dramatic cinematic moment. But what are the roles? It is illusion and allusion. The same uncertainty exists in the image of the couple in evening dress in *Untitled*, 1983 (pl. 61). The graphic arrangement of blacks and whites, along with the fashionable attire, recalls films like *Last Year in Marienbad*. We have no sure way of knowing whether the woman is being victimized or if in fact she is the seductress. We cannot assume that this situation is being controlled by the man, despite his superior position. The identity of the woman shown in the mirror, which would be clarified in film, remains a cipher for each spectator to solve. Cowin employs codified conventions and signs established by other means of visual communication. Lacking a concrete context, the solution lies with the viewer.

In late 1984 and early 1985 Cowin undertook a large (four-by-fifteen-foot) three-part black-and-white work (pl. 60). It is perhaps her most elegant and enigmatic composition, removing her couple, shown metaphorically in the embrace of dancing, from the suburban environment to a thoroughly empty void. An expansive, rich mat black dominates each panel, enveloping the man and woman in their shifting positions. The varying poses and interaction allude to the interpersonal dynamics of a relationship. The figures maintain their anonymity. The hands and arms are silhouetted against the blackness. The figures have at once a sense of motion and stasis, clasping each other in a romantic, stylish slow dance. Although the figures are removed from a real setting, they are not psychologically estranged. As with her other recent

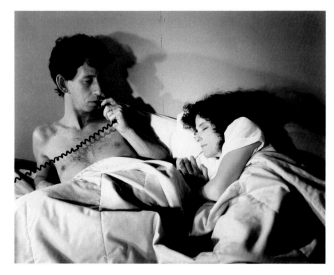

Fig. 4.   *Untitled*, 1983; Ektacolor print; 18⅞ x 24 in. Collection of the artist.

works, Cowin has expunged all but the most essential elements to focus on pose and gesture.

In the early months of 1984 Cowin finally realized a long-standing wish to photograph an older couple. Aging and enduring relationships are the subject of several of her images from the early 1980s. *Untitled*, 1985 (pl. 65), an eerie, dark photograph of an old woman wearing a nightgown, is typical of the mysterious, often nocturnal mood of most works in the exhibition. Again Cowin uses light, white fabric as a foil for the figure, setting it off from the dark, blackish blue background. Against the patterned wallpaper, the intense shadows function as a mute and haunting doppelgänger. The attitude of reflection and remembrance is conveyed by very little information.

In *Untitled*, 1984 (pl. 66), the solitary figure of a young girl, who seems to be waiting while reclining on a chair, is presented in stasis, relaxed and contemplative. The girl, diagonally placed across the picture plane is, like many of Cowin's figures, anonymous and hence archetypal. As in her other thirty-by-forty-inch Cibachrome prints, color is severely limited, virtually nonexistent, and thoroughly subordinated to the dark, black background. The emphasis is on the psychological moment.

The combination of pose, glance, expression, dress, and props in *Untitled*, 1985 (pl. 64), offers multiple, disparate possibilities. The precise identification of the woman rests wholly on the perspective and interpretation brought by the viewer to decode the image. Cowin provides selected, but powerful cues: flowers, bed, formal dress, shoes. Although the work lacks tension, the body position and glance suggest anticipation or exasperation: "The theme is long lasting; the images are long lasting; the possibilities are endless."[7]

NOTES

1.   Julia Hirsch, *Family Photographs: Content, Meaning, Effect* (New York: Oxford University Press, 1981), p. 32.

2.   The packaging of the family is discussed in Erving Goffman, *Gender Advertisements* (Cambridge: Harvard University Press, 1979).

3.   Hirsch, p. 95.

4.   Eileen Cowin, interview with author.

5.   Indeed the first piece sold in the series was a black-and-white photograph.

6.   Cowin admits that for a time she was overly concerned with props and has since rejected many of these images.

7.   Lecture by Cowin, School of the Art Institute of Chicago, March 1985.

PLATE 59

Eileen Cowin, *Untitled*, 1984

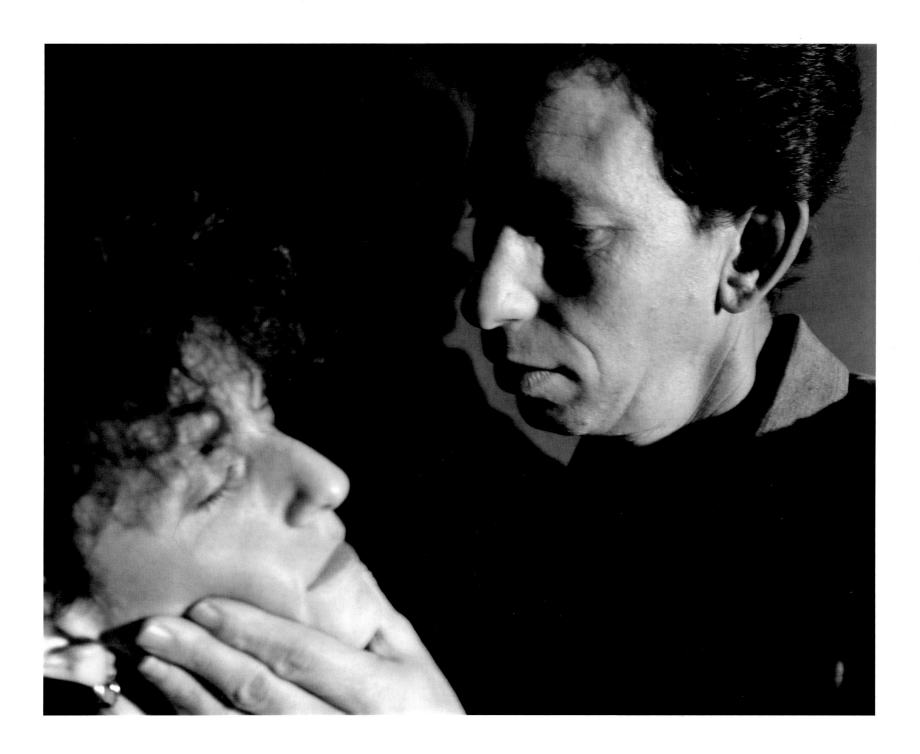

PLATE 60

Eileen Cowin, *Untitled*, 1984–85

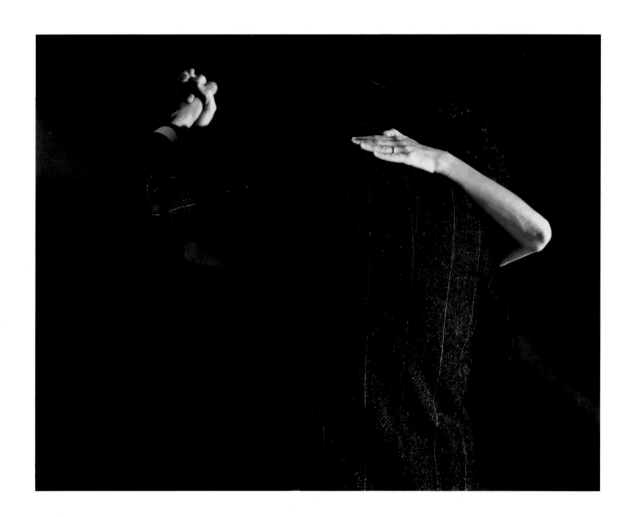
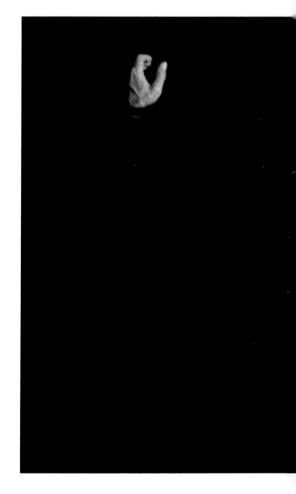

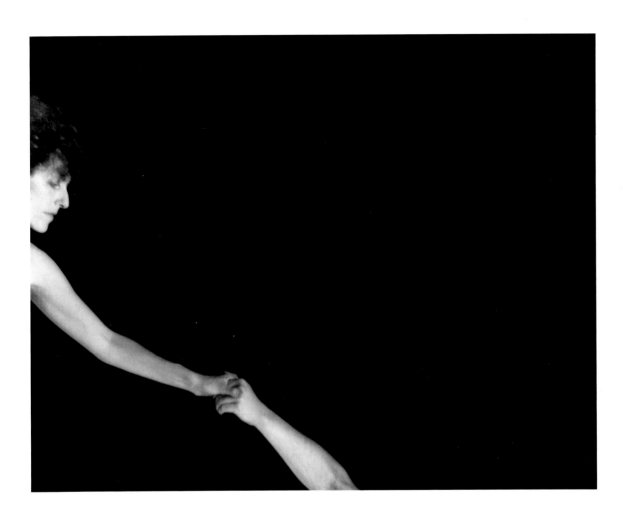

PLATE 61

Eileen Cowin, *Untitled*, 1983

PLATE 62

Eileen Cowin, *Untitled*, 1984

PLATE 63

Eileen Cowin, *Untitled*, 1984

PLATE 64

Eileen Cowin, *Untitled*, 1985

PLATE 65

Eileen Cowin, *Untitled*, 1985

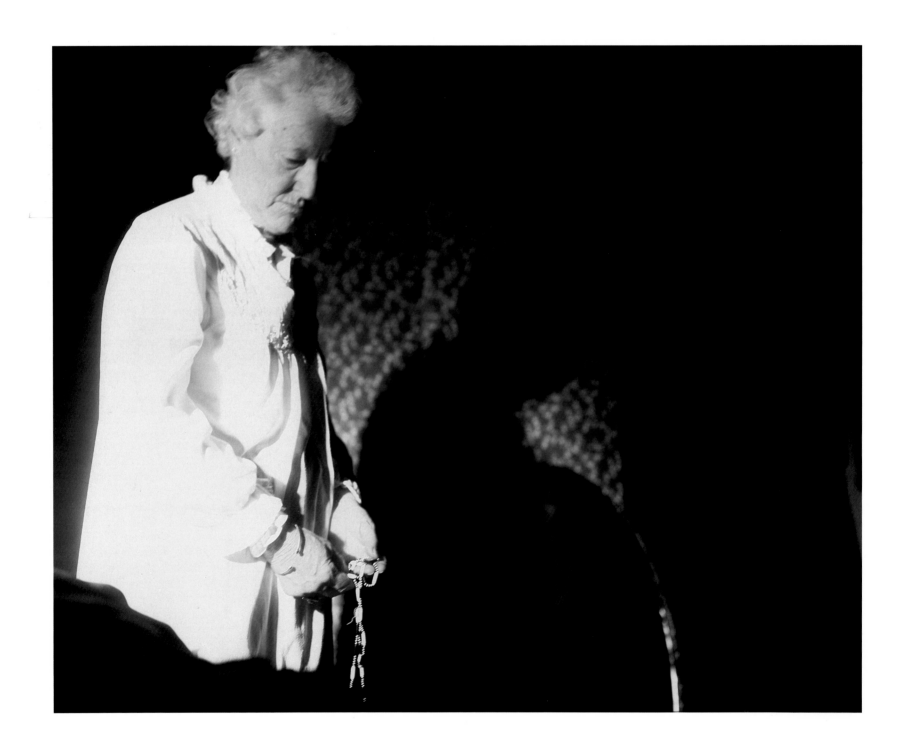

PLATE 66

Eileen Cowin, *Untitled*, 1984

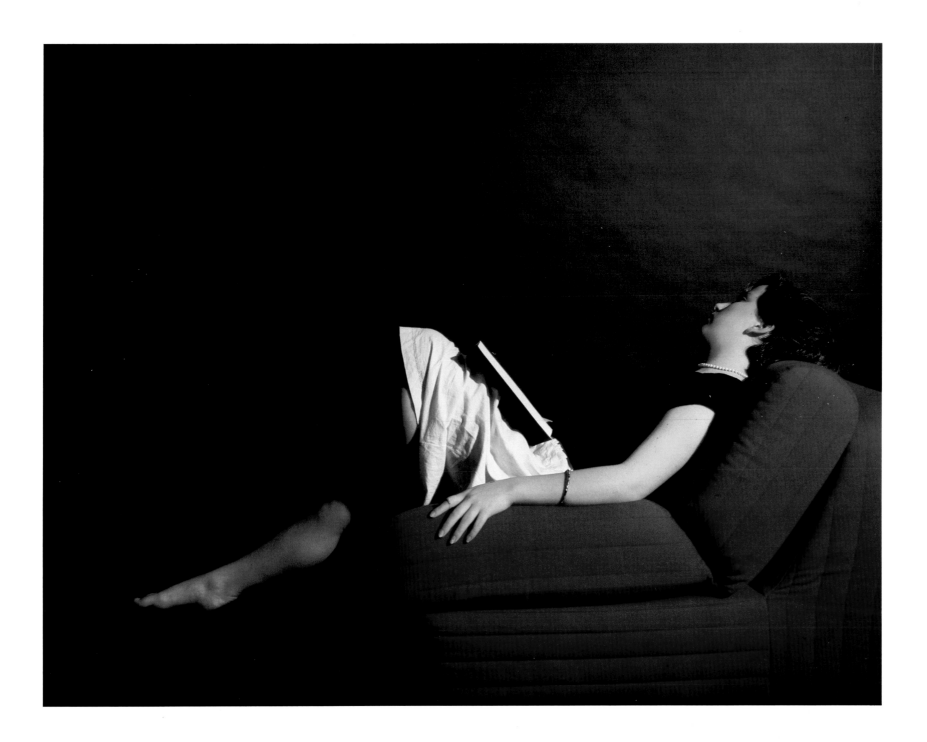

PLATE 67

Eileen Cowin, *Untitled*, 1984

# Biographies and Checklists

## Susan Rankaitis

Born 1949, Cambridge, Mass.
Resides in Inglewood, Calif.

### Education
B.F.A., University of Illinois,
Champaign, 1971.
M.F.A., University of Southern California,
Los Angeles, 1977.

### Grants
National Endowment for the Arts Visual
Artists Fellowship, 1980.

### Selected Recent Solo Exhibitions
LIGHT Gallery, New York, 1984.
International Museum of Photography at
George Eastman House, Rochester,
N.Y., 1983.
LIGHT Gallery, Los Angeles, 1981.
BC Space, Laguna Beach, Calif., 1980.

### Selected Recent Group Exhibitions
*Altered Images*, Seattle Art Museum, 1985.
*Contemporary Constructs*, Los Angeles
Center for Photographic Studies
and Otis Art Institute/Parsons
School of Design (traveled:
Amsterdam), 1984.
*California Photography*, Museum of Art,
Rhode Island School of Design,
Providence, 1982.
*Exchange between Artists, 1931–1982,
Poland–USA*, Musée d'Art
Moderne de la Ville de Paris
(traveled: Dublin, Lódź,
Ulster), 1982.
*Hang Eight*, Foundation Gallery,
New York, 1982.
*Lately in LA*, Washington Project for the
Arts, Washington, D.C., 1982.
*The Photographer as Printmaker*, Ferens
Art Gallery, Hull, England
(traveled: Edinburgh, Barnsley,
Leicester, London), 1981.

### Checklist of the Exhibition
*Inherent in Flight*
September 8–November 27, 1983

*Gold/Water*, 1980
From Fire River series
Combined media photographic monoprint
83 x 41 3/4 in.
Pamela Berg
*Pl. 1*

*Lake*, 1980
From Fire River series
Combined media photographic monoprint
83 x 41 3/4 in.
Collection of the artist
*Pl. 2; detail, fig. 1, p. 11*

*Wing*, 1982
Combined media photographic monoprint
78 1/2 x 42 in.
Collection of the artist
*Pl. 3*

*Flight Plan (Perloff Variation)*, 1983
Combined media photographic monoprint
42 x 77 1/4 in.
Collection of the artist
*Pl. 4*

*Fusion*, 1983
From Flight Plan series
Combined media photographic monoprint
20 x 24 in.
Collection of the artist

*Grey Ghost*, 1983
Combined media photographic monoprint
99 1/2 x 54 in.
Collection of the artist
*Pl. 6*

*L'avion, L'avion*, 1983
Combined media photographic monoprint
56 x 84 in.
Collection of the artist
*Pl. 9*

*Prolate Habitat*, 1983
Combined media photographic monoprint
Two panels, 114 x 42 in. each
Collection of the artist
*Pl. 7; detail, fig. 3, p. 13*

# Richard Misrach

Born 1949, Los Angeles.
Resides in Emeryville, Calif.

*Rain/Slide*, 1983
Combined media photographic monoprint
42 x 73 in.
Collection of the artist
*Pl. 5; fig. 4, p. 14*

*RR Voor RF*, 1983
Combined media photographic monoprint
Three panels, 104 x 56 in. each
Collection of the artist
*Pl. 8; fig. 4, p. 14*

*Tail*, 1983
From Flight Plan series
Combined media photographic monoprint
20 x 24 in.
Collection of the artist
*Fig. 2, p. 11*

## Education
B.A., University of California,
Berkeley, 1971.

## Grants
National Endowment for the Arts Visual
Artists Fellowship, 1984, 1977, 1973.
John Simon Guggenheim Memorial
Fellowship, 1978.
Ferguson Award, 1976.

## Selected Recent Solo Exhibitions
Fraenkel Gallery, San Francisco, 1985.
LIGHT Gallery, New York, 1985.
Etherton Gallery, Tucson, Ariz., 1984.
Honolulu Academy of Arts, 1984.
*A Decade of Photography*, Friends of
Photography, Carmel, Calif., 1984.
Grapestake Gallery, San Francisco, 1983,
1982, 1981.
The Photographers' Gallery, London, 1980.
Young/Hoffman Gallery, Chicago, 1980.

## Selected Recent Group Exhibitions
*Eloquent Light: American Photography,
1945–1980*, Barbizon Art Gallery,
London, 1985.
*New Color*, Museum of Modern Art,
New York, 1984.
*Photography in California, 1945–1980*,
San Francisco Museum of Modern
Art (traveled: Akron, Ohio;
Washington, D.C.; Los Angeles;
Ithaca, N.Y.; Atlanta; San Diego,
Calif.; Essen, West Germany;
Paris), 1984.
*California Photography*, Museum of Art,
Rhode Island School of Design,
Providence, 1982.
*1981 Biennial Exhibition*, Whitney
Museum of American Art,
New York, 1981.
*Photography's Recent Directions*,
De Cordova and Dana Museum
and Park, Lincoln, Mass., 1980.

## Checklist of the Exhibition
*Recent Desert Photographs*
December 8, 1983–February 12, 1984

*San Gorgonio Pass*, 1981
Ektacolor print
26 3/4 x 34 in.
Courtesy Grapestake Gallery,
San Francisco
*Pl. 12*

*St. Jack*, 1981
Ektacolor print
18 1/4 x 23 in.
Courtesy Grapestake Gallery,
San Francisco
*Fig. 2, p. 27*

*Dune Buggy Tracks and St. Jack*, 1982
Ektacolor print
18 1/8 x 23 in.
Collection of the artist
*Pl. 18*

*Foot of St. Jack #1*, 1982
Ektacolor print
18 1/4 x 23 in.
Courtesy Grapestake Gallery,
San Francisco
*Pl. 15*

*Painted Desert, Morning Light*, 1982
Ektacolor print
18 1/4 x 23 in.
Collection of the artist
*Pl. 10*

*Palm Trees*, 1982
Ektacolor print
18 1/4 x 23 in.
Collection of the artist

*San Jacinto Mountains with Storm
Clouds*, 1982
Ektacolor print
18 1/4 x 23 in.
Collection of the artist
*Pl. 13*

*The Santa Fe*, 1982
Ektacolor print
26 3/4 x 34 in.
Courtesy Grapestake Gallery,
San Francisco
*Fig. 4, p. 30*

*Diving Board, Salton Sea*, 1983
Ektacolor print
18 1/4 x 23 in.
Collection of the artist
*Pl. 17*

*Edom Hill Road*, 1983
Ektacolor print
18 1/4 x 23 in.
Collection of the artist
*Pl. 14*

*Palms to Pine Highway*, 1983
Ektacolor print
18 1/4 x 23 in.
Collection of the artist
*Pl. 11*

*Salton Sea Overview*, 1983
Ektacolor print
18 1/4 x 23 in.
Collection of the artist

*Telephone Pole with Full Moon*, 1983
Ektacolor print
18 1/4 x 22 in.
Collection of the artist

*Telephone Pole with San Gorgonio
Pass*, 1983
Ektacolor print
18 1/4 x 22 7/8 in.
Collection of the artist

*Clothesline, Salton Sea*, 1983
Ektacolor print
18 1/4 x 23 in.
Collection of the artist
*Pl. 16*

*Desert Fire #1 (Burning Palms)*, 1983
Ektacolor print
26 3/4 x 34 in.
Courtesy Grapestake Gallery,
San Francisco
*Pl. 19*

*Desert Fire #19 (Mecca)*, 1983
Ektacolor print
18 1/4 x 23 in.
Courtesy Grapestake Gallery,
San Francisco
*Fig. 3, p. 28*

# Mark Klett

Born 1952, Albany, N.Y.
Resides in Tempe, Ariz.

### Education
B.S., Saint Lawrence University,
Canton, N.Y.
M.F.A., State University of New York at
Buffalo (Visual Studies Workshop,
Rochester), 1977.

### Grants
National Endowment for the Arts Visual
Artists Fellowship, 1984, 1982, 1979.
Ferguson Award, 1980.

### Selected Recent Solo Exhibitions
The Art Institute of Chicago, 1984.
Clarence Kennedy Gallery, Cambridge,
Mass., 1984.
Film in the Cities, Saint Paul, Minn., 1984.
Fraenkel Gallery, San Francisco, 1984.
Pace/MacGill Gallery, New York, 1984.
Etherton Gallery, Tucson, Ariz., 1983.
Northlight Gallery, Arizona State
University, Tempe, 1983.
Visual Studies Workshop, Rochester,
N.Y., 1983.

### Selected Recent Group Exhibitions
*Mountain Light*, International Center for
Photography, New York, 1983.
*Color as Form: A History of Color
Photography*, International Museum
of Photography at George Eastman
House (traveled: Washington,
D.C.), 1982.
*Words and Images*, Los Angeles Center for
Photographic Studies, 1982.
*New Landscapes*, Friends of Photography,
Carmel, Calif., 1981.

### Checklist of the Exhibition
*Searching for Artifacts–Photographs of
of the Southwest*
March 8–May 27, 1984

*Beneath the Great Arch, near Monticello,
Utah 6/21/82*, 1982
Gelatin silver print
16 x 20 in.
Los Angeles County Museum of Art;
Gift of Pamela Berg; M.84.28
*Pl. 29*

*Bullet riddled saguaro, near Fountain Hills,
Az 5/21/82*, 1982
Gelatin silver print
16 x 20 in.
Collection of the artist
*Pl. 21*

*Checking the road map: Crossing into
Arizona, Monument Valley 6/22/82*, 1982
Gelatin silver print
16 x 20 in.
Collection of the artist
*Pl. 23*

*Daybreak, where 500,000 people came to
watch the space shuttle Columbia land in the
Mojave Desert, July 4th, 1982*, 1982
Gelatin silver print
16 x 20 in.
Collection of the artist

*Man behind creosote bush, Phoenix, Az
3/7/82*, 1982
Gelatin silver print
16 x 20 in.
Collection of the artist

*Motorcycles speeding past, dirt road near
Apache Jct., Az 10/10/82*, 1982
Gelatin silver print
16 x 20 in.
Courtesy Pace/MacGill, New York
*Fig. 3, p. 43*

*Petroglyphs in the Cave of Life, Petrified
Forest, Arizona 5/31/82*, 1982
Gelatin silver print
16 x 20 in.
Courtesy Pace/MacGill, New York
*Pl. 26*

*Plywood Tee-Pees, Meteor Crater, Az
5/30/82*, 1982
Gelatin silver print
16 x 20 in.
Collection of the artist
*Pl. 22*

*Sedona vista, subdivision, from Chapel of
the Holy Cross, Sedona, Az 4/17/82*, 1982
Gelatin silver print
16 x 20 in.
Collection of the artist
*Pl. 27*

*Vandalized wall, undeveloped subdivision,
Carefree, Arizona 2/27/82*, 1982
Gelatin silver print
16 x 20 in.
Courtesy Pace/MacGill, New York

*View of the Superstition Mtns from the
Salt River October 31, 1982*, 1982
Gelatin silver print
16 x 20 in.
Collection of the artist
*Fig. 4, p. 46*

*Campsite reached by boat through watery
canyons, Lake Powell 8/20/83*, 1983
Gelatin silver print
16 x 20 in.
Courtesy Fraenkel Gallery, San Francisco
*Pl. 25*

*Car passing snake, eastern Mojave Desert
5/29/83*, 1983
Gelatin silver print
16 x 20 in.
Courtesy Pace/MacGill, New York
*Pl. 24*

*Evening storm passing south, Tucson, Az
9/5/83*, 1983
Gelatin silver print
16 x 20 in.
Courtesy Fraenkel Gallery, San Francisco

*First day of summer, evening of the solstice,
Phoenix 6/21/83*, 1983
Gelatin silver print
16 x 20 in.
Collection of the artist

*Pausing to drink, Peralta Creek trail,
Superstition Mtns, Az 1/8/83*, 1983
Gelatin silver print
16 x 20 in.
Collection of the artist
*Fig. 1, p. 42*

*Picnic on the edge of the rim, Grand Canyon,
Az 2/21/83*, 1983
Gelatin silver print
16 x 20 in.
Collection of the artist
*Pl. 20*

*Returning to Phoenix: Start of the rainy
season, near Payson, Az 7/10/83*, 1983
Gelatin silver print
16 x 20 in.
Courtesy Fraenkel Gallery, San Francisco
*Fig. 2, p. 43*

*Roy in a box canyon, Havasupai, Az
4/16/83*, 1983
Gelatin silver print
16 x 20 in.
Collection of the artist

*Running goats: On weathered granite,
Saguaro National Monument, Az
5/7/83*, 1983
Gelatin silver print
16 x 20 in.
Collection of the artist

*Spiral carving facing east, Signal Hill,
5/7/83*, 1983
Gelatin silver print
16 x 20 in.
Collection of the artist
*Pl. 28*

# Wendy MacNeil

Born 1943, Boston.
Resides in Lincoln, Mass.

### Education
B.A., Smith College, 1965.
Studied with Minor White, Massachusetts
    Institute of Technology, 1966–68.
M.A.T., Harvard University, 1967.

### Grants
National Endowment for the Arts Visual
    Artists Fellowship, 1978, 1974.
Massachusetts Arts and Humanities
    Photography Fellowship, 1975.
John Simon Guggenheim Memorial
    Fellowship, 1973.

### Selected Recent Solo Exhibitions
Ryerson Polytechnic Institute,
    Toronto, 1984.
Jewett Art Museum, Wellesley College,
    Mass., 1981.
Yuen Lui Gallery, Seattle, 1980.

### Selected Recent Group Exhibitions
*Coast to Coast*, Houston Center for
    Photography, 1984.
*Images*, Carpenter Center for the Visual
    Arts, Harvard University,
    Cambridge, 1984.
*Platinum and Gold: Image and Process*,
    Jeffrey Fuller Fine Arts,
    Philadelphia, 1984.
*Self as Subject: Visual Diaries by Fourteen
    Photographers*, University Art
    Museum, University of New
    Mexico, Albuquerque, 1983.
*Counterparts: Form and Emotion in
    Photography*, Metropolitan Museum
    of Art, New York, 1982.
*Face to Face*, Alternative Museum,
    New York, 1982.
*Paris Biennale*, 1982.
*Some Contemporary Portraits*,
    Contemporary Arts Museum,
    Houston, 1982.
*Love Is Blind*, Castelli Graphics,
    New York, 1981.
*The Portrait Extended*, Museum of
    Contemporary Art, Chicago, 1980.

### Checklist of the Exhibition
*Family Portraits*
June 21–September 23, 1984

*Adrian Sesto*, 1977; printed 1982
Platinum print on vellum tracing paper
23 1/4 x 18 1/2 in.
Collection of the artist

*Barbara MacNeil*, 1977; printed 1980
Platinum-palladium print on vellum
tracing paper
18 1/2 x 23 1/8 in.
Collection of the artist

*Fred Stone and Father*, 1977; printed 1980
Platinum-palladium print on vellum
tracing paper
18 x 23 in.
Collection of the artist
*Pl. 30*

*Mother (Shane Crabtree) and Daughter
(Mary Townsend)*, 1977; printed 1981
Platinum-palladium print on vellum
tracing paper
18 1/2 x 23 1/8 in.
Collection of the artist

*Ronald MacNeil*, 1977; printed 1980
Platinum-palladium print on vellum
tracing paper
18 1/2 x 23 1/8 in.
Collection of the artist
*Pl. 39*

*Vernon MacNeil*, 1977; printed 1980
Platinum-palladium print on vellum
tracing paper
18 1/2 x 23 in.
Collection of the artist

*Father and son (Endel and Tonu Kalam)*,
1978; printed 1980
Platinum-palladium print on vellum
tracing paper
18 x 23 1/8 in.
Collection of the artist

From *The Class Portrait, First Year
Graduate Students in Photography, Rhode
Island School of Design*, 1979–80;
printed 1982
*Page Carr*
23 1/8 x 18 5/8 in.
*Steve Petegorsky*
23 1/8 x 18 5/8 in.
*Jamie Wolff*
23 1/4 x 18 5/8 in.
*Fig. 6, p. 60*
Platinum-palladium prints on vellum
tracing paper
Collection of the artist

From *The Group Portrait of the Eight
Tenured Members of the Art Department,
Wellesley College (by rank)*, 1980;
printed 1981
*James O'Gorman*
18 1/2 x 23 1/16 in.
*Lilian Armstrong*
18 5/8 x 23 1/8 in.
*Pl. 34*
*Richard Wallace*
18 1/2 x 23 1/8 in.
*Peter Fergusson*
18 1/2 x 23 1/8 in.
*Eugenia Parry Janis*
18 5/8 x 23 1/8 in.
*Pl. 33*
*Miranda Marvin*
18 1/2 x 23 1/8 in.
Platinum-palladium prints on vellum
tracing paper
Collection of the artist

*Snyder Family Portrait*, 1980; printed 1984
*Virginia F. Snyder*
23 x 18 7/16 in.
*John C. Snyder, M.D.*
23 x 18 1/2 in.
*Wendy Snyder MacNeil*
23 x 18 7/16 in.
*John M. Snyder*
23 x 18 7/16 in.
*Gordon M. Snyder*
23 x 18 1/2 in.
Platinum prints on vellum tracing paper
Collection of the artist
*Figs. 1–5, p. 59*

From *Ronald*, an on-going portrait begun
in 1980
*Ronald*, 1981; printed 1982
18 1/2 x 23 in.
*Ronald*, 1981; printed 1982
18 1/2 x 23 in.
*Fig. 7, p. 61*
*Ronald, 40th Birthday*, 1981; printed 1982
18 7/16 x 23 in.
*Pl. 38*
*Ronald*, 1981; printed 1982
18 9/16 x 23 in.
*Ronald*, 1983; printed 1984
18 1/2 x 23 in.
*Ronald*, 1983; printed 1984
18 9/16 x 23 in.
Platinum-palladium prints on vellum
tracing paper
Collection of the artist

*Andrew Ruvido and Robyn Wessner*, 1981;
printed 1982
Palladium print on vellum tracing paper
18 7/16 x 23 in.
Collection of the artist
*Pl. 31*

From *The Group Portrait of the 25 Fellows
of the Center for Advanced Visual Studies,
M.I.T.*, 1983–84; printed 1984
*Otto Piene*
*Pl. 35*
*Rus Gant*
*Pl. 36*
*Betsy Connors*
Palladium prints on vellum tracing paper
23 x 18 1/2 in.
Collection of the artist

*My Grandmother's Hand*, 1983;
printed 1984
Platinum print on vellum tracing paper
18 3/8 x 23 in.
Collection of the artist
*Pl. 32*

# John Pfahl

Born 1939, New York.
Resides in Buffalo, N.Y.

### Education
B.A., Syracuse University, N.Y., 1961.
M.A., Syracuse University, 1968.

### Grants
New York State Council on the Arts,
Creative Artists Public Service
Grant, 1979, 1975.
National Endowment for the Arts Visual
Artists Fellowship, 1977.

### Selected Recent Solo Exhibitions
La Jolla Museum of Contemporary Art,
Calif., 1984.
Northlight Gallery, Arizona State
University, Tempe, 1984.
University Art Museum, University of
New Mexico, Albuquerque, 1984.
Film in the Cities, Saint Paul, Minn., 1983.
Friedus/Ordover Gallery, New York, 1983.
Sheldon Memorial Art Gallery, Lincoln,
Nebr., 1983.
Tortue Gallery, Santa Monica, Calif., 1982.
Friends of Photography, Carmel,
Calif., 1981.
Grapestake Gallery, San Francisco, 1981.
Delahunty Gallery, Dallas, 1980.
Robert Friedus Gallery, New York,
1982, 1980.
Visual Studies Workshop, Rochester,
N.Y., 1980.

### Selected Recent Group Exhibitions
*Color in the Summer*, The Brooklyn
Museum, N.Y., 1984.
*New Acquisitions*, Center for Creative
Photography, University of
Arizona, Tucson, 1984.
*Rochester: An American Center of
Photography*, International Museum
at George Eastman House,
Rochester, N.Y., 1984.
*Arranged Image Photography*, Boise
Gallery of Art, Idaho, 1983.
*Photographes et Paysages, XIX–XXme
siècles*, Centre National d'Art et de
Culture Georges Pompidou,
Paris, 1983.
*Photography in America*, Tampa Museum
of Contemporary Art, Fla., 1983.
*The New Color Photography*, Everson
Museum of Art of Syracuse and
Onondaga County, N.Y., 1981.

### Checklist of the Exhibition
*Power Places*
October 26–December 30, 1984

*San Onofre Nuclear Generating Station,
San Clemente, California*, June 1981
Ektacolor print
13 x 18 in.
Courtesy Friedus/Ordover Gallery,
New York
*Fig. 1, p. 74*

*Niagara Power Project, Niagara Falls,
New York*, September 1981
Ektacolor print
13 x 18 in.
Courtesy Tortue Gallery, Santa Monica,
California
*Pl. 48*

*Crystal River Nuclear Plant, Crystal River,
Florida (evening)*, January 1982
Ektacolor print
12 3/4 x 17 3/4 in.
Courtesy Tortue Gallery, Santa Monica,
California
*Pl. 44*

*Crystal River Nuclear Plant, Crystal River,
Florida (morning)*, January 1982
Ektacolor print
12 3/4 x 17 1/2 in.
Courtesy Friedus/Ordover Gallery,
New York

*Ginna Nuclear Plant, Lake Ontario,
New York*, February 1982
Ektacolor print
12 3/4 x 18 in.
Collection of the artist
*Pl. 49*

*Fort Saint Vrain Nuclear Plant, South
Platte River, Colorado*, March 1982
Ektacolor print
12 3/4 x 18 in.
Courtesy Tortue Gallery, Santa Monica,
California

*Indian Point Nuclear Plant, Hudson River,
New York*, May 1982
Ektacolor print
13 x 18 in.
Courtesy Friedus/Ordover Gallery,
New York
*Pl. 47*

*Three Mile Island Nuclear Plant,
Susquehanna River, Pennsylvania*, May 1982
Ektacolor print
13 x 18 1/4 in.
Courtesy Tortue Gallery, Santa Monica,
California
*Pl. 43*

*Bruce Mansfield Power Plant, Ohio River,
Pennsylvania*, August 1982
Ektacolor print
13 x 18 in.
Courtesy Tortue Gallery, Santa Monica,
California
*Fig. 2, p. 75*

*Windmill, Department of Energy, Boone
County, North Carolina*, August 1982
Ektacolor print
13 x 18 in.
Courtesy Tortue Gallery, Santa Monica,
California

*Peach Bottom Nuclear Plant, Susquehanna
River, Pennsylvania*, September 1982
Ektacolor print
13 1/4 x 18 in.
Collection of the artist

*Diablo Dam, Skagit, Washington*,
October 1982
Ektacolor print
12 3/4 x 17 3/4 in.
Courtesy Tortue Gallery, Santa Monica,
California

*Four Corners Power Plant, Farmington,
New Mexico (evening)*, October 1982
Ektacolor print
13 x 18 in.
Courtesy Friedus/Ordover Gallery,
New York
*Pl. 40*

*Four Corners Power Plant, Farmington,
New Mexico (morning)*, October 1982
Ektacolor print
12 3/4 x 17 1/2 in.
Collection of the artist
*Pl. 45*

*Grand Coulee Power Plant*, October 1982
Ektacolor print
12 3/4 x 17 1/2 in.
Courtesy Friedus/Ordover Gallery,
New York

*San Juan Power Plant, Farmington,
New Mexico*, October 1982
Ektacolor print
12 3/4 x 17 3/4 in.
Courtesy Friedus/Ordover Gallery,
New York

*Trojan Nuclear Plant, Columbia River,
Oregon*, October 1982
Ektacolor print
13 x 18 in.
Courtesy Friedus/Ordover Gallery,
New York

*Ontario Power Plant, Niagara Falls,
Ontario, Canada*, March 1983
Ektacolor print
12 3/4 x 17 3/4 in.
Courtesy Friedus/Ordover Gallery,
New York
*Pl. 42*

*The Geysers Power Plant, Mayacamas
Mountains, California*, June 1983
Ektacolor print
12 3/4 x 17 3/4 in.
Collection of the artist
*Fig. 3, p. 76*

*Hoover Dam, Colorado River, Nevada*,
June 1983
Ektacolor print
12 2/3 x 17 3/4 in.
Courtesy Friedus/Ordover Gallery,
New York

*Lake Mead, Colorado River, Nevada*,
June 1983
Ektacolor print
12 3/4 x 17 3/4 in.
Courtesy Friedus/Ordover Gallery,
New York

# Barbara Kruger

Born 1945, Newark, N.J.
Resides in New York.

*Pacific Gas and Electric Plant,*
*Morro Bay, California,* June 1983
Ektacolor print
12 3/4 x 17 3/4 in.
Courtesy Tortue Gallery, Santa Monica,
California

*Rancho Seco Nuclear Plant, Sacramento*
*County, California,* June 1983
Ektacolor print
12 3/4 x 17 3/4 in.
Courtesy Tortue Gallery, Santa Monica,
California

*Palo Verde Nuclear Plant, Centennial Wash,*
*Arizona,* April 1984
Ektacolor print
13 1/2 x 18 7/16 in.
Collection of the artist
*Fig. 4, p. 78*

*Glen Canyon Dam, Colorado River,*
*Arizona,* June 1984
Ektacolor print
13 1/4 x 18 1/8 in.
Collection of the artist

*Navaho Generating Station, Lake Powell,*
*Arizona (evening),* June 1984
Ektacolor print
13 3/16 x 18 in.
Collection of the artist

*Navaho Generating Station, Lake Powell,*
*Arizona (morning),* June 1984
Ektacolor print
13 1/8 x 18 1/8 in.
Collection of the artist
*Pl. 46*

*ERB-1 Nuclear Plant, Big Southern Butte,*
*Idaho,* July 1984
Ektacolor print
13 3/16 x 18 1/4 in.
Collection of the artist

*Idaho Power and Light Plant, Shoshone*
*Falls, Idaho,* July 1984
Ektacolor print
13 1/4 x 18 1/8 in.
Collection of the artist
*Pl. 41*

## Education
Syracuse University, N.Y., 1967–68.
Parsons School of Design, New York,
1968–69.
School of Visual Arts, New York, 1968–69.

## Selected Recent Solo Exhibitions
Houston Institute of Contemporary Art,
Tex., 1985.
Wadsworth Athenaeum, Hartford,
Conn., 1985.
Annina Nosei Gallery, New York,
1984, 1983.
Crousel/Hussenot Gallery, Paris, 1984.
Kunsthalle Basel, Switzerland, 1984.
Nouveau Musée, Lyon, France, 1984.
Rhona Hoffman Gallery, Chicago, 1984.
Institute of Contemporary Art,
London, 1983.
Larry Gagosian Gallery, Los Angeles,
1983, 1982.

## Selected Recent Group Exhibitions
*New York: Ailleurs et Autrement,*
Animation-Recherché-
Confrontation, Musée d'Art
Moderne de la Ville de Paris, 1985.
*1985 Biennial Exhibition,* Whitney
Museum of American Art,
New York, 1985.
*Content: A Contemporary Focus,* Hirshhorn
Museum and Sculpture Garden,
Smithsonian Institution,
Washington, D.C., 1984
Institute of Contemporary Art, Boston,
Mass., 1984.
*Photography Used in Contemporary Art,*
National Museum of Modern Art,
Kyoto, Japan, 1984.
*Private Symbol/Social Metaphor,* Sydney
Biennial, Australia, 1984.
*Currents,* Institute of Contemporary
Art, 1983.
Mary Boone Gallery, New York, 1983.
*1983 Biennial Exhibition,* Whitney
Museum of American Art, 1983.
*Starting Points of Young Critical Artists,*
Kunstverein, Bonn, West Germany,
1983.
*Documenta 7,* Kassel, West Germany, 1982.
*Frames of Reference,* Whitney Museum of
American Art, 1982.

*Image Scavengers,* Institute of
Contemporary Art, University of
Pennsylvania, Philadelphia, 1982.
*Venice Biennale,* Italy, 1982.
*Nineteen Emergent Artists,* The Solomon R.
Guggenheim Museum, New York,
1981.
*Public Address,* Annina Nosei Gallery,
New York, 1981.

## Checklist of the Exhibition
*Untitled Works*
January 17–March 17, 1985

*Untitled,* 1982
Silver print
40 1/2 x 49 1/2 in., framed
Eileen and Peter Broido
*Pl. 51*

*Untitled,* 1983
Silver print
72 x 48 in., framed
Courtesy Larry Gagosian Gallery,
Los Angeles
*Pl. 53*

*Untitled,* 1983
Silver print
three panels, 59 x 97 in. each, framed
Henry S. McNeil, Jr., Dresher,
Pennsylvania
*Pl. 54; fig. 1, p. 91*

*Untitled,* 1983
Silver print
121 7/8 x 72 7/8 in., framed
Museum of Contemporary Art, Chicago;
Gift of Paul and Camille Oliver-Hoffmann
*Pl. 55*

*Untitled,* 1983
Silver print
72 x 48 in., framed
Courtesy Larry Gagosian Gallery,
Los Angeles
*Pl. 52*

*Untitled,* 1984
Silver print
123 1/2 x 72 1/8 in., framed
Memphis Brooks Museum of Art,
Tennessee; Puchased by Art Today and
Susan Austin, Eleanor Baer, Robert
Fogelman, Allen and Minna Glenn, Wil
and Sally Hergenrader, Mickey Laukhuff,
Bickie McDonnell, Stella Menke, Jan
Singer, Marie Thompson, Ruth Williams,
and Richard and Barbara Wilson;
84.5.2 a–c
*Pl. 57*

*Untitled,* 1984
Silver print
76 x 73 in., framed
Louis B. Thalheimer, Baltimore, Maryland
*Pl. 58*

*Untitled,* 1984
Silver print
48 x 76 in., framed
Daniel Wolf, New York
*Pl. 50*

*Untitled,* 1984
Silver print
73 x 46 1/2 in., framed
Courtesy Rhona Hoffman Gallery,
Chicago
*Pl. 56*

# Eileen Cowin

Born 1947, Brooklyn, N.Y.
Resides in Santa Monica.

### Education
B.S., State University College of New York
at New Paltz, 1968.
M.S., Illinois Institute of Technology,
Chicago, 1970.

### Selected Recent Solo Exhibitions
Viviane Esders, Paris, 1985.
H. F. Manes Gallery, New York, 1984.
University of Arizona, Tucson, 1984.
Orange Coast College, Costa Mesa, Calif.,
1983, 1980.

### Selected Recent Group Exhibitions
*Eileen Cowin and John Divola: New Work,
No Fancy Titles*, La Jolla Museum
of Contemporary Art, 1985.
*Anxious Interiors*, Laguna Beach Museum
of Art, Calif. (traveled: Anchorage,
Juneau, Fairbanks, Aka.; Banff,
Canada; Tampa, Fla.; Utica, N.Y.),
1984.
*Contemporary Constructs*, organized by
Los Angeles Center for
Photographic Studies and held
at Otis Art Institute of the
Parsons School of Design (traveled:
Amsterdam, San Francisco), 1984.
*Masking/Unmasking: Postmodern
Photography*, Friends of
Photography, Carmel, Calif., 1984.
*Photography in California, 1945–1980*, San
Francisco Museum of Modern Art
(traveled: Akron, Ohio;
Washington, D.C.; Los Angeles;
Ithaca, N.Y.; Atlanta; San Diego,
Calif.; Essen, West Germany;
Paris), 1984.
*1983 Biennial Exhibition*, Whitney
Museum of American Art, New
York, 1983.
*Self as Subject: Visual Diaries by Fourteen
Photographers*, University of New
Mexico, Albuquerque, 1983.
*The Alternative Image*, John Michael
Kohler Arts Center, Sheboygan,
Wis., 1982–83.
*The Image Scavengers*, Institute of
Contemporary Art, University of
Pennsylvania, Philadelphia,
1982–83.

*California Photography*, Museum of Art,
Rhode Island School of Design,
Providence, 1982.
*Studio Work: Photographs by Ten Los
Angeles Artists*, Los Angeles County
Museum of Art, 1982.
*Love Is Blind*, Castelli Graphics,
New York, 1981.
*New Voices Two: Six Photographers
Concept/Theatre/Fiction*, Allen
Memorial Art Museum, Oberlin,
Ohio, 1981.
*The Photographer as Printmaker*, Ferens
Art Gallery, Hull, England
(traveled: Edinburgh, Barnsley,
Leicester, London), 1981.
*The New Vision*, LIGHT Gallery,
New York (traveled), 1980.

### Checklist of the Exhibition
*The Facts Never Speak for Themselves*
July 11–September 15, 1985

*Untitled*, 1983
Gelatin silver print
48 x 60 in.
Collection of the artist
*Pl. 61*

*Untitled*, 1984
Gelatin silver print
48 x 60 in.
Collection of the artist
*Pl. 59*

*Untitled*, 1984
Gelatin silver print
48 x 60 in.
Collection of the artist
*Pl. 62*

*Untitled*, 1984
Cibachrome print
30 x 40 in.
Collection of the artist
*Pl. 63*

*Untitled*, 1984
Cibachrome print
30 x 40 in.
Collection of the artist
*Pl. 66*

*Untitled*, 1984
Cibachrome print
40 x 30 in.
Collection of the artist
*Pl. 67*

*Untitled*, 1984–85
Gelatin silver print
Three panels
48 x 64 1/2 in. (left, center)
48 x 60 in. (right)
Collection of the artist
*Pl. 60*

*Untitled*, 1985
Cibachrome print
30 x 40 in.
Collection of the artist
*Pl. 64*

*Untitled*, 1985
Cibachrome print
30 x 40 in.
Collection of the artist
*Pl. 65*